ASSUMING THE GUISE

WILLIAMS COLLEGE MUSEUM OF ART

ASSUMING THE GUISE

*African Masks Considered
and Reconsidered*

Williams College Museum of Art
Main Street
Williamstown, Massachusetts 01267

Library of Congress
Cataloging-in-Publication Data

Assuming the Guise: African masks
 considered and reconsidered.
p. 0 cm.
Exhibition held at Williams College Museum of Art
 Oct. 12, 1991-Mar. 1, 1992
Organized by guest curator, Suzanne Bach.
ISBN 0-913697-13-3 (pbk.)
 1. Masks–Africa, West–Exhibitions.
 2. Decorative arts–Africa, West–History–20th century–Exhibitions.
 3. Decoration and ornament. Primitive–Africa. West—Exhibitions.
 I. Bach, Suzanne. II. Williams College. Museum of Art.
NK1087.A83 1991
730'.966'0747441—dc20

91-50617
CIP

This publication documents the exhibition
"Assuming the Guise: African Masks
Considered & Reconsidered," organized by
the Williams College Museum of Art and
presented from October 12, 1991 through
March 1, 1992.

CONTENTS

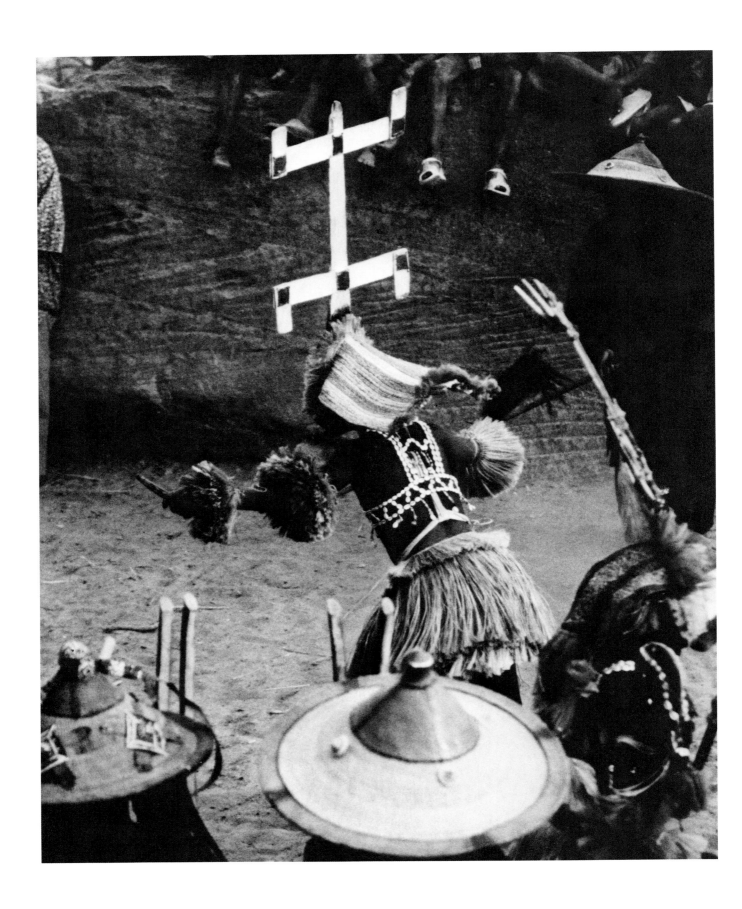

Museums in an academic setting have a special obligation to teach. "Assuming the Guise: African Masks Considered and Reconsidered" has provided an opportunity to fulfill this responsibility in an unprecedented and rather unusual way. Through the efforts of Eva Grudin, Williams College Lecturer in Art, and her students in Art 285–Art of West Africa, the exhibition is slated to be disassembled and reconfigured according to new or alternative interpretations of the meaning(s) of its objects. This change will take place midway through the exhibition's run, after the students have had a chance to study the exhibition thoroughly and to examine the conventions and thinking that surround the collecting, interpretation, and display of African and other ethnographic art and artifacts. This project embraces the notion that the perception or understanding of other cultures is a complex undertaking and one that has become increasingly scrutinized in the academic arena as well as in the larger environment of an ever-shrinking "international" world.

On an immediate level, "Assuming the Guise" continues the Williams College Museum of Art's commitment to the presentation of non-Western art. With this exhibition and two others planned for this year ("Lands Wide Open: Photography and Expansionism in British India and the American West" and "Sites of Recollection: Four Altars and a Rap Opera"), WCMA will continue to explore both historical and contemporary aspects of cross-cultural perceptions. These explorations of how we perceive other cultures as well as our own will be informed by related programs that result from collaboration with the College's Multicultural Center and a number of academic departments. The Museum

staff's creative, managerial, and production efforts for the series of exhibitions and programs have again demonstrated that WCMA employs an extremely talented and dedicated group of professionals.

While "Assuming the Guise" has called on a range of resources on the Williams campus for its presentation and interpretation, the exhibition would not have been possible without the contribution of community member Suzanne Bach, who extended her already generous volunteer efforts to the Museum by acting as guest curator. Suzanne tirelessly provided the professional experience she gained through many years as the director of the Tribal Arts Gallery in New York to select and assemble the exhibition. The exhibition, and especially the catalogue, have also benefitted from the generous written and photographic contributions of Dr. Gilbert Graham, whose collection makes up almost half of the exhibition. The Museum is very grateful to Gil and Roda Graham as well as Albert Gordon, Suzanne and Robert Bach, Herbert and Shelley Cole, Penelope Naylor, Dr. Jonathan and Lois Stolzenberg, and the Mead Art Museum at Amherst College, who all so unselfishly parted with their precious masks and headdresses for the duration of the exhibition.

Finally we acknowledge and thank the primarily unknown artists who produced the meaningful and amazing objects that WCMA is so fortunate to be able to present. It is our sincere hope that the exhibition will promote a greater understanding of the rich and divergent cultures of Africa that produced these artists.

– Linda Shearer, *Director*

– W. Rod Faulds, *Associate Director*

Kanaga mask, one of numerous masks dancing in the Dogon village of Tireli, January 1987 (in the foreground, elders in large hats). Photograph by Gilbert Graham.

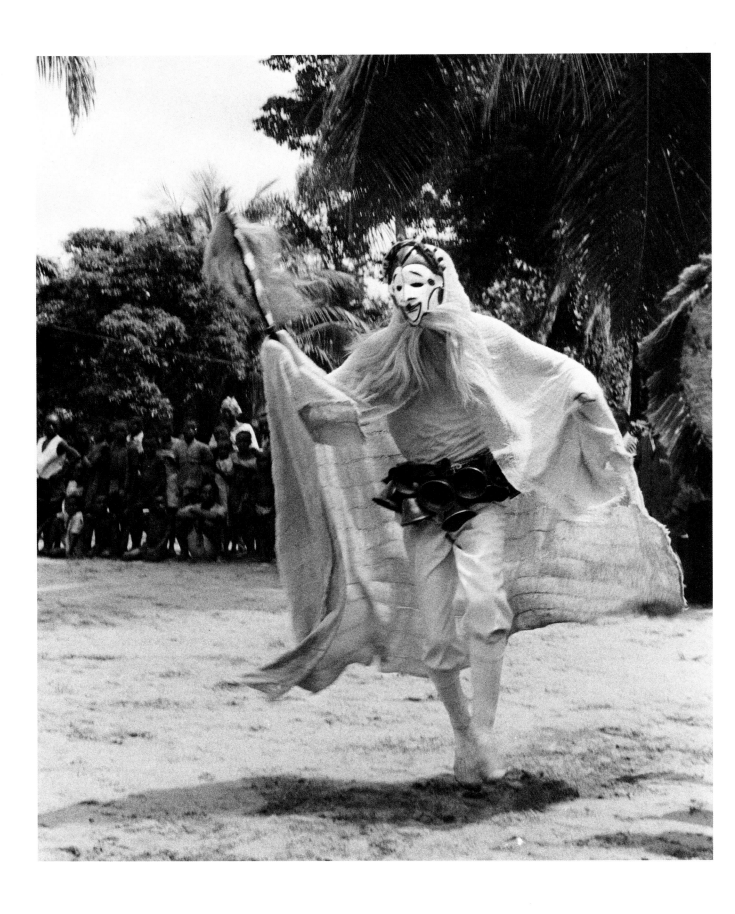

It was with a sense of adventure that I approached this exhibition, as I have never ceased to be astounded by the beauty, inventiveness, and sheer power of African sculpture. As I let my eye wander over favorite collections and pieces, aesthetics and the significance of the masks within their cultures were the prime considerations in making my selections.

Our exhibition's innovative two-phased approach both challenges viewers and offers Williams College students an opportunity for direct participation. Phase one, "Assuming the Guise: African Masks Considered," first focuses on the mask's visual impact, encouraging the viewer to experience and respond to expressive qualities and formal attributes. Only limited explanatory labels are displayed. The viewer is then invited to refer to the gallery guide and catalogue, which provide ethnographic background. This permits us to examine how knowledge of the mask's original function in its cultural context affects our appreciation and understanding.

Phase two, "Assuming the Guise: African Masks Reconsidered," is the reinstallation of the exhibition by the students. One issue that students will address is the separation of works from their original context and their representation in an alien setting. Another issue deals with designating as art, objects that in their original context are not called art.

The collectors who have contributed to the exhibition are very special to me personally. To my brother, Albert Gordon, I owe my involvement in the world of African art, my memorable African trips, and the many exciting years of close collaboration in the Tribal Arts Gallery. I first met Roda and Gil Graham when they visited our gallery in 1983. I clearly remember their initial acquisition of African sculpture, the amazingly swift escalation of their passion, and the astounding discernment of taste and knowledge as their collection expanded.

I am also grateful to the other lenders: Penelope Naylor and Jonathan and Lois Stolzenberg, gallery friends of long standing; the cooperative staff of the Mead Art Museum at Amherst College; and Herbert Cole of the University of California, an alumnus of Williams College, whose field experience enriches the catalogue.

My special thanks to William Siegmann, who took precious time out from an important seminar in Gabon to write his insightful essay. I am indebted to Eva Grudin both for conceiving the idea of a two-phased exhibition and for her helpful suggestions for the catalogue entries. It was my exceptional good fortune to have Rod Faulds, Associate Director of the Williams College Museum of Art, as the project manager, assisted by his able summer intern Janet Temos. Thanks also go to Susan Dillmann for her skillful editing of the catalogue, and to George Abbott for capably overseeing the installation of the exhibition. And without the patient support and assistance of my husband, Bob, I would never have been able to meet my deadlines.

My volunteer association with WCMA has given me much joy. Most rewarding are the warmth and openness of the entire staff, the stimulation of museum professionals, and the refreshing dimension of student involvement. Working with the Museum in a curatorial capacity has added to my appreciation of its contribution to the cultural life of Williams College and the larger community.

– Suzanne Bach, *Guest Curator*

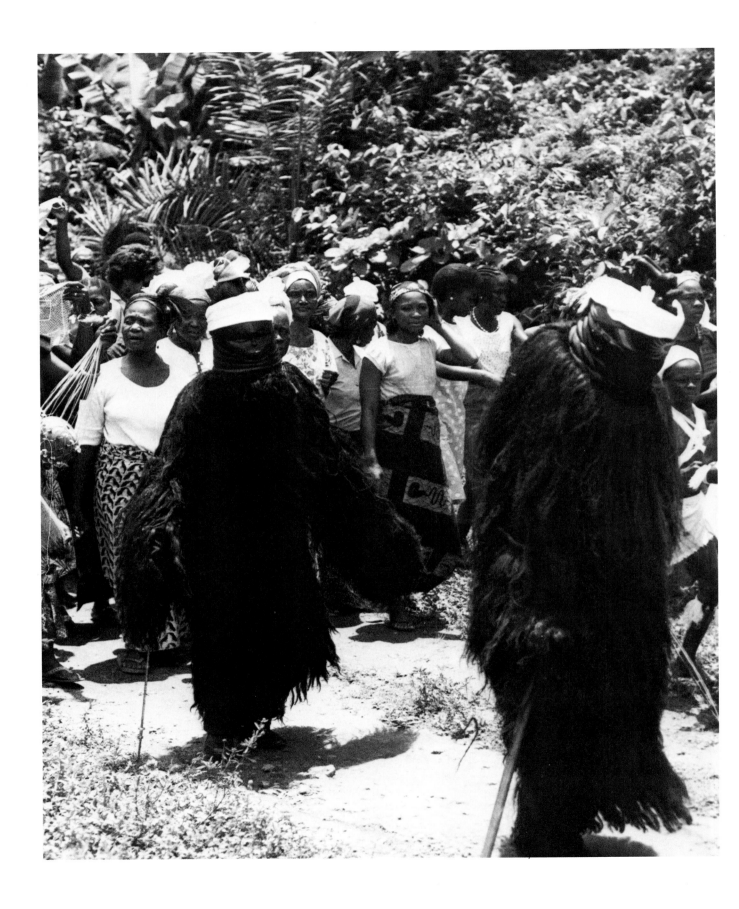

SPIRITS, MEN & MASKS

by William C. Siegmann

Masks and masquerades are known to virtually every culture and have been found in every era, yet no continent is more widely known for its masking traditions than Africa. Among the earliest examples of these traditions are those found on rock paintings from Tassili-N-Ajjer; more than 5,000 years old, they depict dancers wearing masks. Today masks continue to be the most characteristic African art form and remain the central feature of ceremonial and social life.

When we view African masks mounted in a gallery for exhibition, we may well appreciate their sculptural qualities and value them for their aesthetic expression, but what we miss is witnessing them as part of a vital and dynamic ensemble, energizing and shaping a way of life.

A wooden face that we collect and display is only part of a costume. The ensemble is worn by an individual who, in assuming the guise of the mask, is transformed from his role in everyday life to that of an animator of a spirit force. The spirit comes alive through music, dance, and the social context in which it appears.

The functions of masks are as complex and varied as their forms. Masks validate political authority, initiate youths into adulthood, protect communities from witchcraft, assist the spirits of the deceased in their transition to the realm of the ancestors, teach social values, and simply entertain. Regardless of their specific roles, however, almost all masks are associated with strong religious and spiritual beliefs that influence their creation, appearance, performance style, the way they are used, and the way a community responds to them.

Although traditional, religious, and cosmological views are by no means uniform in Africa, there are

certain widely shared concepts that help shape attitudes and beliefs about masks. Fundamentally, the world is thought to be filled with a vast number of unique and personalized supernatural beings, which, although invisible to ordinary mortals, affect them in a multitude of ways. These spirits inhabit streams, rivers, rocks, hills, forests, and trees, where they control nature and intervene in the affairs of people.

The spirits have many things in common with people, such as emotions and desires, and often want to participate in the world as tangible beings. Hans Himmelheber (1964) has written extensively about such beliefs among the Dan. For example, he points out that only by entering into the world of people can spirits satisfy their craving for companionship, solicitude, food, drink, music, physical beauty, and personal adornment. To obtain satisfaction for these needs, spirits render assistance to their human benefactors.

Like men, spirits are concerned with power, status, and identity. Thus, interaction between people and spirits is not random; each must know the other. To establish this relationship, a spirit comes to a man in a dream and reveals its name, powers, and nature as well as the material form it wishes to take.

The basic nature of the relationship is tutelary. The spirit protects its human benefactor from human enemies and the powers of the unseen world including those of other spirits attached to rival groups or individuals.

A spirit may choose a number of ways in which to be activated. It can be embodied in nonfigurative accumulations of magical elements, in sculpted images, or in one of the most common forms—masks, complete

Procession of Sande *women's society masks in Karpebli, Liberia, September 1986. Photograph by William C. Siegmann.*

with associated costumes, music, and performance styles.

In selecting their physical manifestations, some spirits choose to be embodied in human forms with features reflecting an idealized sense of beauty. Others choose dehumanized forms and features, and still others emphasize animal characteristics. These features are consistent with the goals of the spirit to awe, impress, terrify, or amuse. In a sense, the form of the mask, dictated by the spirit, interpreted by the person to whom it appears, and implemented by the carver, is an aesthetic contract. The costume that accompanies the mask in performance is designed to augment the features of the face.

The placation and subsequent goodwill of the spirit is dependent upon its acceptance of the mask and costume. Since the mask and costume are expected to express the spirit's individual personality, it is no wonder that there is such great stylistic variance among masks. The need to distinguish the special powers of each mask is frequently demonstrated by the addition of numerous powerful and magical objects such as horns, teeth, and leather talismans.

In some African cultures the process of spirits being made manifest is even more highly individualized by encouraging young men to develop their own relationships with spirit forces and create their own masks. In other cultures men's societies tightly regulate the use of masks, the number of masks in a village, and the audiences who are permitted to see performances. Although African masks and their ownership and regulations may vary from one ethnic group to another, wherever they appear, they function as links between the tangible human world and the unseen spirit world.

Select Sources:

Cole, Herbert M., ed. *I Am Not Myself: The Art of African Masquerade*. Los Angeles: Museum of Cultural History, University of California at Los Angeles, 1985.

Himmelheber, Hans. "Die Geister und ihre irdischen Verkorpungen als Grundvorstellungen in der Religion der Dan." *Baessler Archiv N.F.* 12 (1964): 1-88.

Siegmann, William C. *Rock of the Ancestors: Namoa Koni (Liberian Art and Material Culture from the Collections of the Africana Museum)*. Suakoko, Liberia: Cuttington University College, 1977.

• • •

William C. Siegmann is Associate Curator of African, Oceanic, and New World Arts at The Brooklyn Museum. He completed his master of arts and master of philosophy degrees at Indiana University, and has extensive research experience in West Africa, primarily in Liberia and Sierra Leone.

One of about twenty-five lineage mask groups participating in a public commemorative death celebration in Ngashie Quarter, Kingdom of Oku, Cameroon, in 1976. Photograph by Tamara Northern.

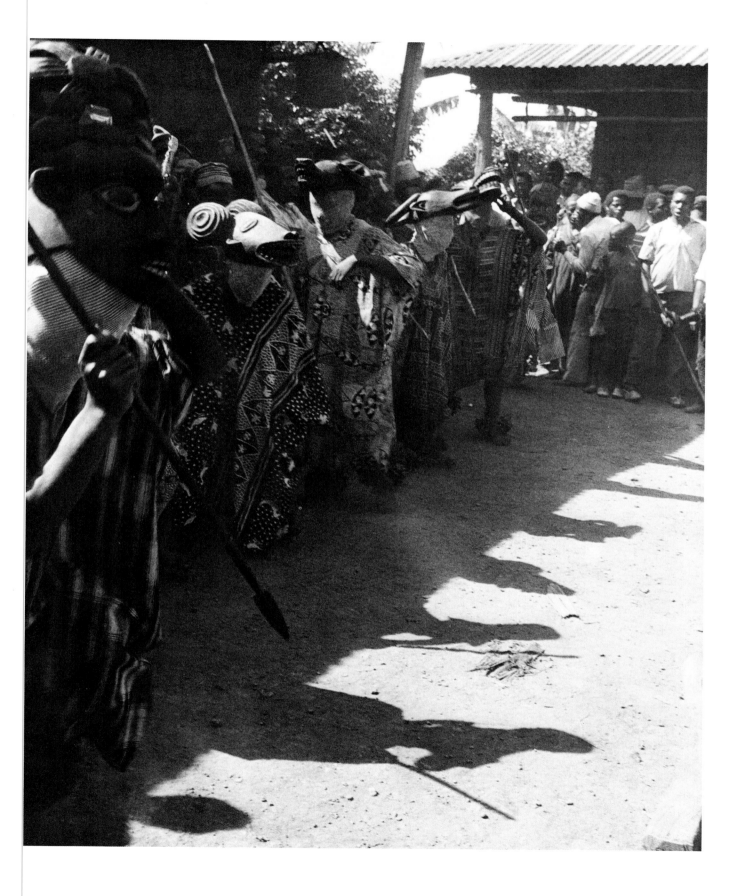

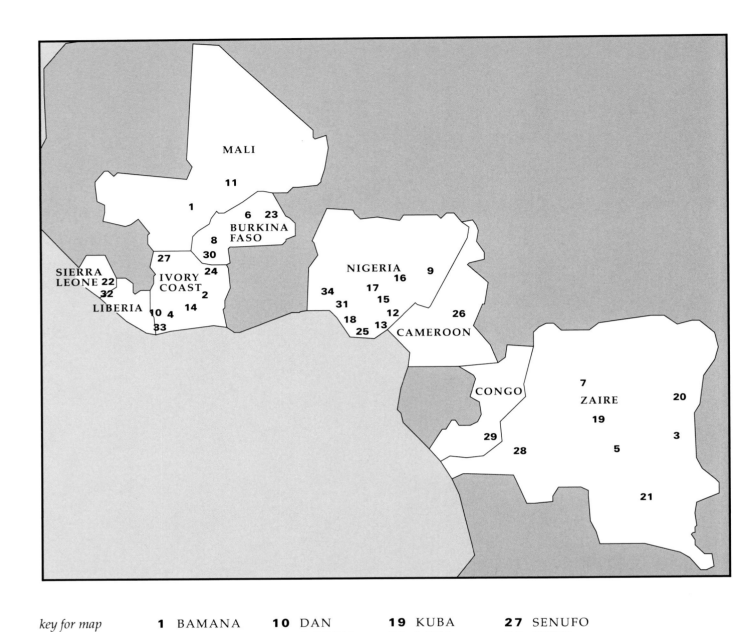

key for map

1	BAMANA	**10**	DAN	**19**	KUBA	**27**	SENUFO
2	BAULE	**11**	DOGON	**20**	LEGA	**28**	SUKU
3	BEMBE	**12**	EJAGHAM	**21**	LUBA	**29**	TSAYE
4	BETE	**13**	EKET	**22**	MENDE	**30**	TUSSIA
5	BIOMBO	**14**	GURO	**23**	MOSSI	**31**	URHOBO
6	BOBO	**15**	IBIBIO	**24**	NAFANA	**32**	VAI
7	BUDJA	**16**	IDOMA	**25**	OGONI	**33**	WE
8	BWA	**17**	IGBO	**26**	OKU,	**34**	YORUBA
9	CHAMBA	**18**	IJO		Kingdom of		

area of enlargement

CATALOGUE OF
THE EXHIBITION

a note about the entries:

Given the nature of African art, its
material, and the manner in which it
is collected, it is very difficult to date.
Consequently, unless specified in the
text, all masks are by unknown artists
and are twentieth century. The dimen-
sion listed in each entry is the height
of the object.

The descriptive entries for the masks
have been written by four contribu-
tors; their names, indicated by initials
at the end of each entry, are:
S.B., Suzanne Bach
H.M.C., Herbert M. Cole
G.G., Gilbert Graham
E.U.G., Eva Ungar Grudin

1
BAMANA
Mali
13 in. (33 cm.)
wood
Collection of Robert and Suzanne Bach

The Bamana have numerous societies divided into hierarchical age-group associations called *ton* that use masks during traditional initiation rituals. The highest level of the men's initiation society, the *Kore*, represents the culmination of years of intensive spiritual training and uses zoomorphic masks to remind man of his own animal nature (Zahan 1974: 22, 23). Today, the spread of Islam and Western influence have caused a serious decline in these original age-group functions.

According to Dr. Pascal Imperato, this monkey mask depicts a baboon, and served as entertainment (1991: personal communication). The dancer would mimic the monkey's gestures and movements to the accompaniment of music (drums, bells, singing) and elicit lively audience response. Since the baboon is commonly identified with arrogance, an undesirable trait, the spectators would react with scorn (Imperato 1975: 62-70).

The most prominent feature of this stylized animal mask is the exaggerated nose that continues the line of the rounded forehead with only minor interruption. The recessed facial plane and open mouth suggest its simian nature.
– S.B.

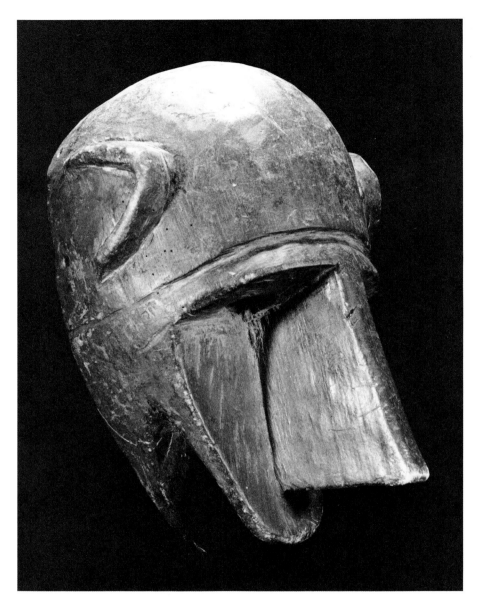

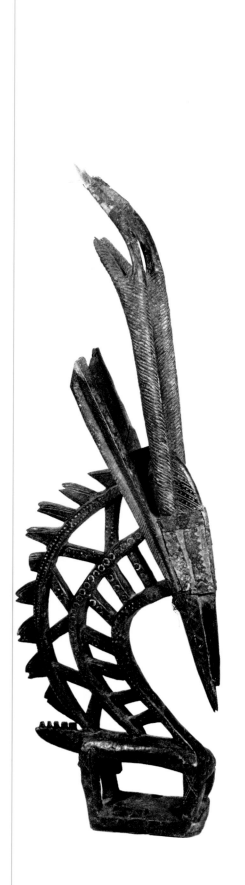

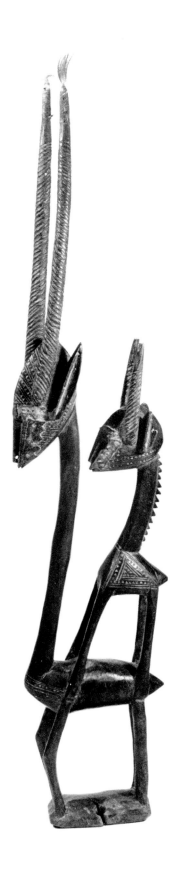

2 & 3
BAMANA
Mali
42 in. (107 cm.)
wood, cloth, and metal
The Graham Collection

Believed to be half animal and half man, *Chi Wara (Tyi Wara)*, the Bamana mythical hero, appeared on earth to teach man how to cultivate the soil. Farming, essential for survival, is considered the most honored of all professions, and agricultural rituals play a major role among the Bamana (Imperato 1970: 8). Always performed in pairs, the male and female antelope crests, also called *Chi Wara*, express the notion of union. They are attached to the top of the head by basketwork, and are danced at planting and harvest ceremonies by champion farmers of the preceding year.

In addition, the male figure represents the sun; the female, the earth; and the fiber costume, rain. Such representation signifies gender cooperation required for a successful harvest and, by extension, the survival of the community (Zahan in Vogel 1981: 22-24; Brink in Vogel 1981: 24, 25). Albert Gordon has identified the pair as originating in the village of Ngolobougou (1983: personal communication).

The abstract stylized male antelope has an openwork mane in two tiers. The long tapered head, bearing evidence of old repairs, is surmounted by spiral grooved split horns. The female has a cylindrical body on angled legs and supports a fawn on her back; their triangular faces are compact and the horns are vertical.
– G.G.

4
DOGON
Mali
17 in. (44 cm.)
wood, fiber, and sacrificial material
The Graham Collection

This rare mask, collected in Mali in
1936, may relate to the Dogon myth
of the origin of weaving and speech
as described in Marcel Griaule's *Con-*
versations with Ogotommeli. The central
figure is a *Nommo* demigod. The fiber
bundle attachments may be the spin-
dles of yarn for the shuttle, and the
triangular form above is most likely a
heddle pulley attachment.

"At sunrise on the appointed day
the seventh ancestor Spirit spat out
eighty threads of cotton; these he
distributed between his upper teeth
which acted as the teeth of a weaver's
reed. . . . By opening and shutting his
jaws, the Spirit caused the threads of
the warp to make the movements
required in weaving. . . . As the
threads crossed and uncrossed, the
Spirit's forked tongue pushed the
thread of the weft to and fro . . . for
the Spirit was speaking while the
work proceeded . . . [speech was]
woven in the threads and formed part
and parcel of the cloth. They were the
cloth and the cloth was the Word"
(Griaule 1965: 27, 28).

This rectangular mask is divided
by a wide central ridge, which in the
frontal plane forms the nose, mouth,
and part of the forehead. Viewed
from the side the central ridge be-
comes a *Nommo*, its zigzag body end-
ing in feet that become the mouth of
the mask. The surface is covered with
a grey-black sacrificial patina.
– G.G.

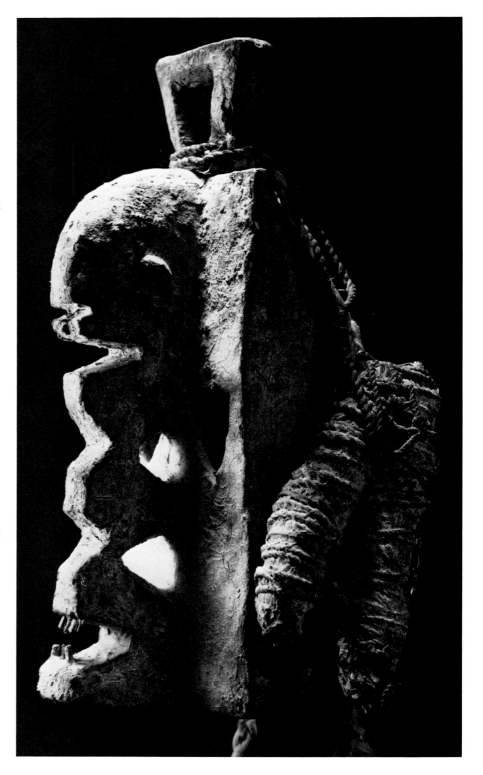

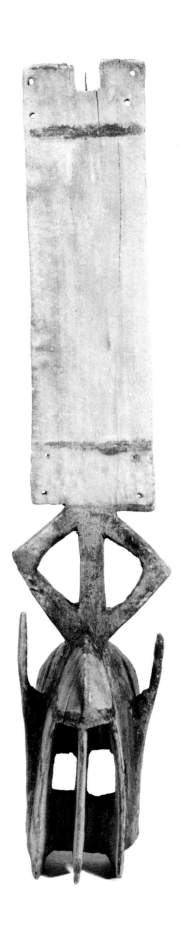

5
DOGON
Mali
36 in. (92 cm.)
wood and pigment
The Graham Collection

Kanaga masks function in elaborate rituals that are believed to transport the soul of a deceased family member away from the village to join the ranks of the ancestors. These rituals, and the spectacular dances during which large numbers of *Kanaga* masqueraders appear, honor the deceased and add status to his descendents (Ezra 1988: 69). In a complicated choreographed dance, the wearer bends at the waist, swinging his torso and head so that the top of the mask almost touches the ground.

This abstract face mask in rectangular form has a deeply recessed facial plane and eyes. The superstructure, which is missing the two crossbars normally found on masks of this type, has carved double triangles on the narrow plank crest. Parts of the crest show traces of dark polychroming on light, weathered wood; the edge is pierced for the costume attachment.
– *G.G.*

6
BWA
Burkina Faso
33 in. (84 cm.)
wood, pigment, and metal
The Graham Collection

The Bwa have numerous animal masks that represent mythical characters and include several types of fish and other water dwellers. Although the Bwa are primarily farmers, they also hunt, fish, and, more recently, raise cattle. This mask, a composite of land animal and fish, is worn so that the dancer can see through the open mouth. Called *Basi*, the mask "performs a fluid, swimming dance during which an elder attempts to catch it with a basketry fish trap" (Roy 1987: 266, no. 222). The period of masking is from March to the beginning of the rainy season in May (Roy 1987: 256-274).

This zoomorphic mask is surmounted by a large fish tail. Raised polychromed triangular, straight, and zigzag patterns cover the mask, creating an unbalanced tension in an otherwise solid form. A fiber costume, traditionally red or black, is usually attached to the mask.
– G.G.

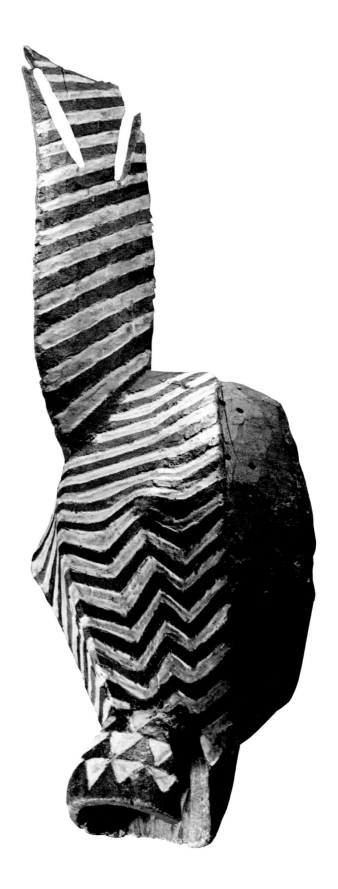

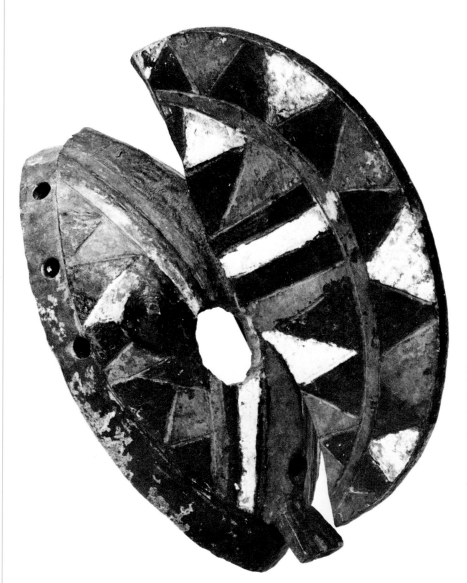

7
BWA
Burkina Faso
10 in. (25 cm.)
wood and pigment
The Albert F. Gordon Collection

Bwa village life is dominated by the all-important cult of *Do*, which acts as a link between man and the untamed forces of nature. This abstract secret society mask would likely have been worn to evoke *Hombo*, protective spirit of the blacksmith clan. Wooden masks function in multiple religious and secular celebrations such as initiations, memorial services, and market day dances. According to Christopher Roy, "clans compete to give the most elaborate and innovative performances" and Bwa masquerades are vivid pageants of movement, form, and color (1987: 288, 262-274).

Bold triangular patterns are carved in shallow bas-relief and pigmented black, white, and deep earth-red. This highly abstract oval face mask is bisected by a prominent crest. Long colored strands of raffia would have been attached to the rim-holes, cloaking the dancer's identity.
– S.B.

8

MOSSI

Burkina Faso
12 in. (30 cm.)
wood, pigment, fiber, and rope
The Albert F. Gordon Collection

Mossi masks, believed to embody the collective ancestor spirit, represent totems sacred to each particular clan's origin myth. "The animal which is the totem of the clan is inseparable from the souls of the living clan members . . . , and from the souls (*kyma*) of the clan's ancestors" (Roy 1987: 96). The totem motif represented by this mask is *Wan-noraogo*, rooster, with its characteristic cockscomb augmented by a small bird. Worn tilted on the forehead and attached to a costume of long raffia strands, the mask functions in a protective capacity and plays a vital role at burials and funerals of clan elders (Roy 1987: 143).

The mask is incised and polychromed in vivid earth-toned geometric patterns. The conical helmet has a long protruding beak and concentric circular eyes on either side of the ridged central crest. The remaining black raffia costume strands are attached to holes around the perimeter.
– S.B.

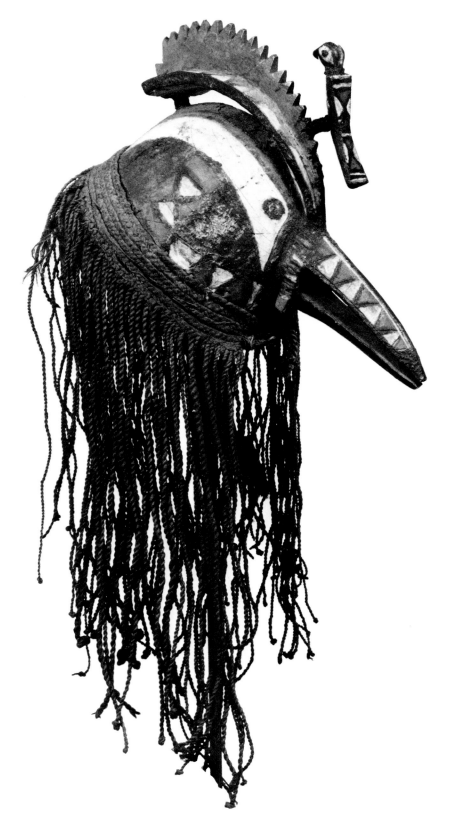

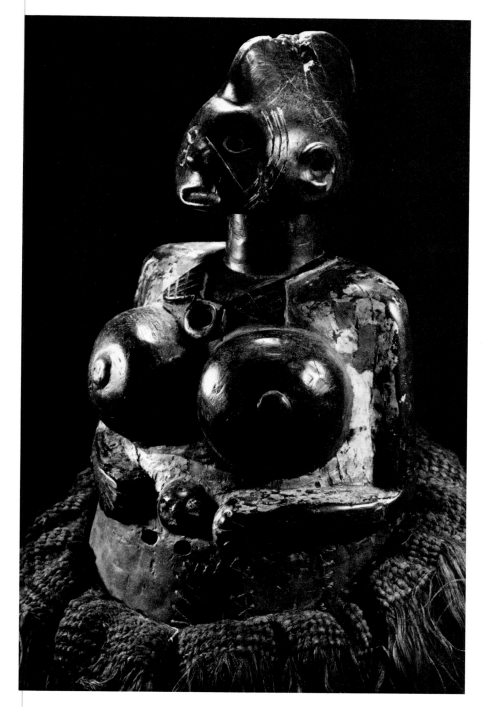

9
MOSSI

Burkina Faso
19 in. (48 cm.) without costume
wood, pigment, and fiber
Collection of Robert and Suzanne Bach

This rare and atypical helmet is a southwestern Mossi-style mask representing either a Fulani woman or, more likely, a Mossi woman. (Roy 1989: personal communication). The central crested coiffure represents the traditional women's hairstyle called *gkyonfo*, and the incised ritual cosmetic scarification, particularly the slant across the cheek from the bridge of the nose, are typically Mossi (Roy 1987: 158, 107). Since Mossi masks function primarily in a protective capacity at funerals and initiations and are associated with totemic animals, the carved crocodiles on the back of the torso may represent a particular clan totem.

The full rounded breasts and the protruding umbilicus suggest fertility. A carved necklace of amulets adorns the neck and the costume attachment of partially woven raffia is typical of Mossi masks. A deep black patina is enriched by polychromed accents and local repairs attest to long use.
– S.B.

10
MOSSI
Burkina Faso
29 in. (74 cm.)
wood and pigment
The Graham Collection

This important *Yali* ritual mask is worn with a fiber costume that completely obscures the dancer. According to Christopher Roy, the mask represents a protective dwarf bush spirit, which is usually danced by a boy, a fact seldom acknowledged by the Mossi. The mask speaks a language only the initiated can comprehend. High- and low-pitched sounds are made by blowing or sucking air through a reed held between the dancer's teeth (Roy 1987: 138, 139).

Carved from a single piece of light wood, the inward curving rectangular shape is further emphasized by bands of red, white, and black, the earth colors for the Mossi. A central ridge of rectangular projections extends from forehead to chin, and elongated narrow ellipses on each side of the ridge serve as eye holes. (Illustrated: Roy 1987: 141, no. 112.)
– G.G.

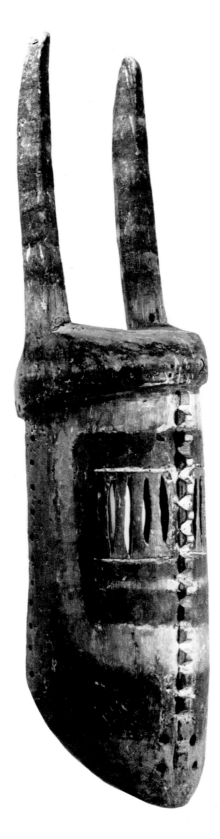

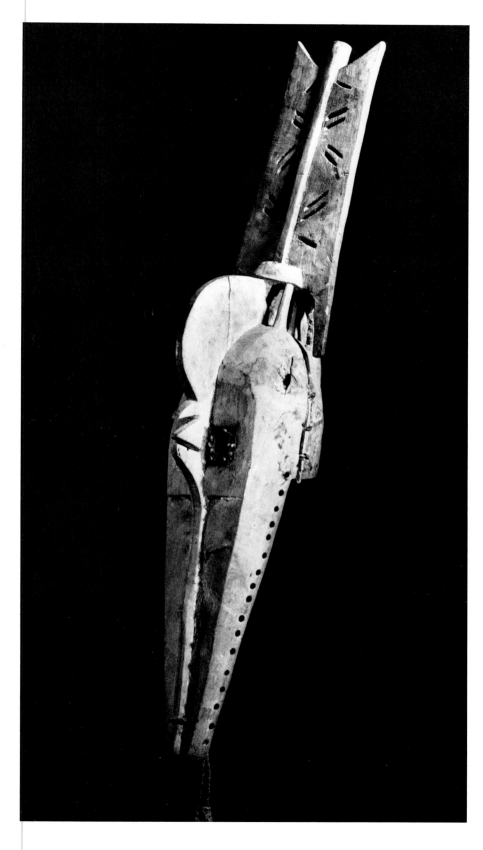

11
BOBO
Burkina Faso
42 in. (107 cm.)
wood and pigment
Collection of Robert and Suzanne Bach

According to Bobo cosmology, the creator god gave man his son *Dwo*, the mask, to act as a link to the spirit world and help man maintain equilibrium in his daily acts. Masks are considered the embodiment of *Dwo* and the carving of masks is the exclusive province of the blacksmiths. Although the form of this mask resembles the sacred *Nwenka* masks, which are carved for ritual use, the rooster-like medial crest indicates it may belong to the category of entertainment masks called *Bole* (Roy 1991: personal communication; 1987: 314-352).

The elongated face of this light wood helmet, bisected by a sagittal crest, dramatically changes when seen in profile. Rectangular eyes are surrounded by bright red seeds. The abstract openwork superstructure has a diagonal design, and traces of red and blue geometric forms remain on the weathered surface.
– *S.B.*

12
TUSSIA
Burkina Faso
20 in. (51 cm.)
wood, rope, and cane
The Graham Collection

Totemic clan animals called *Kable* are represented in Tussia helmets, but only buffalo helmets are made of wood. The mythic buffalo progenitor is an image of fierce aggressive power, strength, and speed. In multipurposed celebrations lasting fifteen days, these masks are danced to bring health, rich harvests, and fertility, and to drive evil forces from the village. According to Christopher Roy, men and married women join the lineage head in dances held in front of his house. Since it is believed that participation before marriage might cause infertility, unmarried women are excluded (Roy 1987: 362-369).

The helmet has large attached curving horns and is surmounted by an abstract horned buffalo. The flat rectangular face is divided by a raised flattened nose that joins a sloping brow with incisions suggesting hair. The legs separate the cylindrical body from the helmet, creating a space that almost allows the animal to float. When the wearer dons this helmet, the large outer horns suggest that he too becomes a buffalo. (Illustrated: Drewal 1988: 17.)
– G.G.

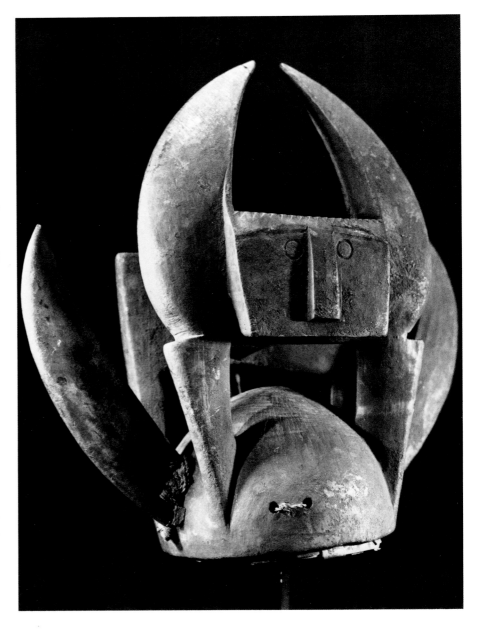

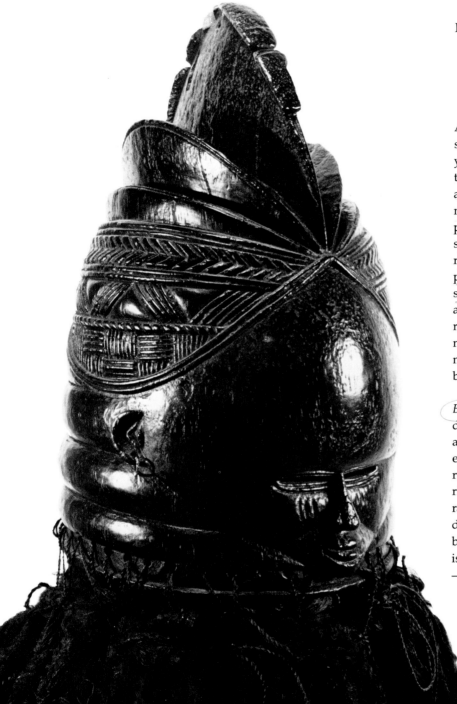

13
MENDE
Sierra Leone
14 in. (36 cm.)
wood, fiber, and metal
The Graham Collection

After many months of secluded instruction by initiation society elders, young women are ready to assume their adult roles. At that time, they are welcomed back into the community with masked dances by powerful priestesses who control the *Sande* society. The mask and black-dyed raffia costume epitomize propriety, pride, mental and physical composure, and beauty. The dancer is silent although her movements may be rapid and vigorous. *Sande* society masks are exceptional because, unlike most African masks, they are danced by and for women (Boone 1986).

Called *Sowei*, and sometimes *Bundu*, this helmet mask has a classic diamond-shaped face with high unadorned forehead, pierced horizontal eyes, and small nose and mouth. The right ear is adorned with a metallic ring. The lower portion of the elaborate coiffure is covered with geometric designs, and the neck is formed in broad rippling rings. Black-dyed raffia is tied to the lower perforations.
– G.G.

14
VAI / MENDE (?)
Liberia / Sierra Leone (?)
18 in. (46 cm.)
wood, pigment, and metal
The Graham Collection

The *Sande* initiation society preaches and teaches confidence, cleaniness, authority, and sweetness. These are illustrated in the black oiled shiny *Sowei* masks seen elsewhere in this catalogue (see #13). On the other hand, this *Gonde* mask, also danced by women, is boisterous, joking, and rude—the very antithesis of *Sowei*. Both *Sowei* and *Gonde* are spirit masks and may dance at the same time. With these masks, the *Sande* society depicts the two extremes of human experience: *Sowei* represents positive values through the traditional image of ideal womanhood: serious, beautiful, elegant, and rich. *Gonde* represents failure: coarse, dishevelled, irreverent, and somewhat grotesque (Boone 1986: 30, 39-40).

The flat white face is surmounted by a black coiffure of three horizontal ridges. The area of the unevenly placed eyes shows evidence of old repair. The rim is perforated for costume attachment.

–G.G.

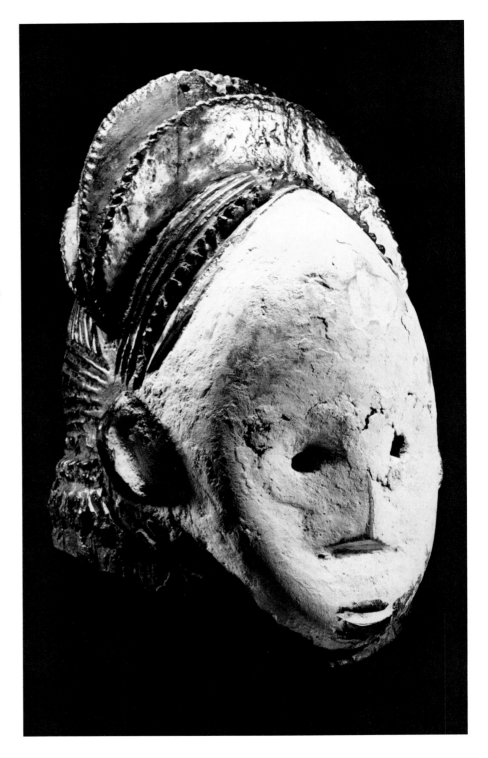

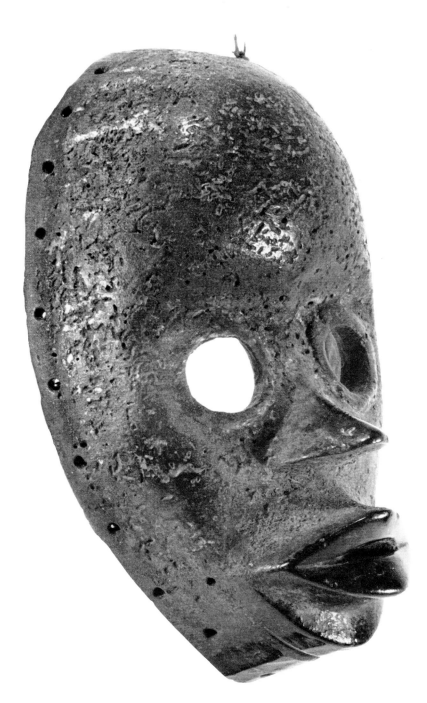

15
DAN

Liberia/Ivory Coast
9 in. (23 cm.)
wood and metal
The Graham Collection

During the dry season, noon winds can suddenly accelerate and the risk of fire in Dan villages increases. When roofs were made of thatch (most are now made of metal), it was essential that the village be protected. Firefighter masks such as this *Zapei Ge* did not dance, but patrolled the village to assure that all cooking fires were promptly extinguished (Fischer 1978: 21). They overturned the cooking pots and punished the offending women. *Zapei Ge* wore a leaf headdress, a costume made of coarse cloth and fiber, and always carried a stick (Fischer and Himmelheber 1984: 45).

The oval face mask displays a slightly prominent forehead, round eyes with minimally raised tubular borders, curving nose, and proportional protruding lips. Traces of red and white pigment remain. The partially eroded surface suggests that bark beetles had been at work beneath the former cloth covering. This beautiful mask dates from the late 19th or early 20th century.
– G.G.

16
WE
Liberia/Ivory Coast
15 in. (38 cm.)
wood, snakeskin, horn, and metal
The Graham Collection

The We believe the world is divided
between the village (people, man-
made objects, domestic animals) and
the forest (wild animals, raw mate-
rials, uncleared fields, spirits). The
masked spirit wears a costume made
of things from both the village and
the forest, thus connecting the two
worlds. The power of We masks may
be enhanced by potent forest symbols
such as horns, leather, snakeskins,
and large teeth (Haley in Cole 1985:
49-50). The moveable lower jaw, ac-
cording to Monni Adams, is an indica-
tion of the mask's power to communi-
cate and command; when the mask
"speaks" (using non-human lan-
guage), the jaw moves (1991: personal
communication).

The attached articulated lower jaw
is studded with metal teeth. The facial
planes angle to form a central ridge
ending in a broad snakeskin-covered
nose. Forward curving horns almost
meet above a broad forehead, and the
woven raffia cloth coiffure is embroi-
dered with cowrie shells. Small cres-
cent-shaped horns hang over slanted
slit eyes. The dark brown surface has
a white kaolin band across the eyes to
the ears, which are separately carved
and inserted into side openings.
– G.G.

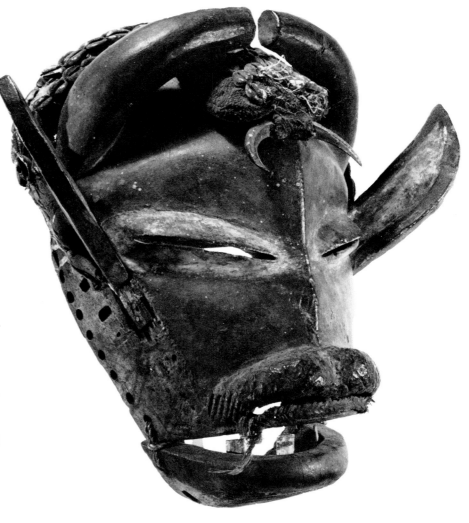

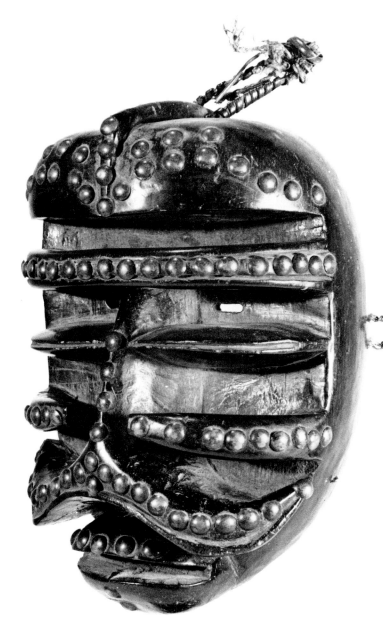

17
BETE

Ivory Coast
11 in. (23 cm.)
wood, metal, and fiber
The Graham Collection

Bete farmers and hunters must cope with a particularly hostile environment. Control of the supernatural and untamed forces of nature is effected through the mask, which serves as intermediary between the spirit world and the village. Masked dancers also perform at ceremonies honoring local notables, and officiate at funerals of important men (Rood 1969: 37-43).

The rich dark brown face of the mask is studded with metal brads. The mask features a frontal ridge like a gorilla, tusks like a wart hog, a mustache like a lion, a chin like a monkey, and a tongue like a snake or lizard, yet somehow it retains its human quality.
– G.G.

18
GURO
Ivory Coast
13.5 in. (34 cm.)
wood, pigment, and mirrors
The Albert F. Gordon Collection

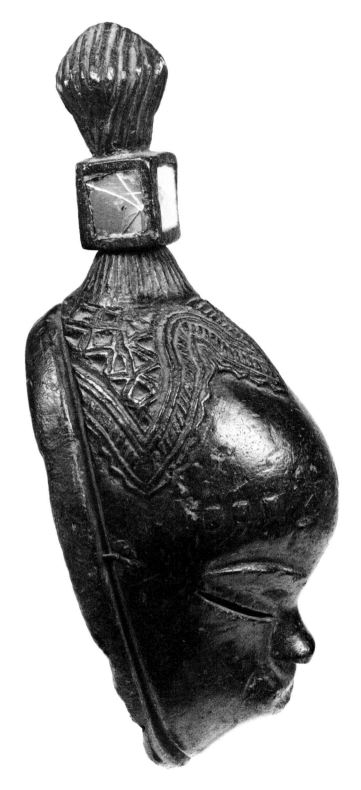

Among the northern Guro, sacred masks are honored by sacrificial offerings and danced at important funerals, memorial ceremonies, and special secular events. Idealized female *Gu* masks such as this depict a "gentle and contented state of being" (Fischer and Homberger 1986: 10). *Gu* is the wife of *Zamble*, a mythical being represented by an elegant zoomorphic male mask. Danced by a man, *Gu* wears rattles on her ankles, an antelope skin on her back, and "appears in sequence after her mate. . . . As *Gu* dances only to vocal and flute music, the drums stop playing when she makes her entrance. Her movements are . . . restrained and simple, though occasionally she will perform a mime sequence" (Fischer and Homberger 1986: 16). This example closely resembles the work of the master of Buafle, who lived in the early decades of this century (Fischer and Homberger 1986: 11, fig. 7).

When viewed in profile, the mask exhibits the classic Guro S-shaped curve formed by the forehead, nose, and chin. The graceful sweep of the facial planes is further enhanced by a rich glossy surface patina. The elaborate tripartite coiffure is surmounted by an incised knob inset with mirrors. Composed serene features, including downcast eyes and a small mouth, contribute to the personification of idealized beauty.
– S.B.

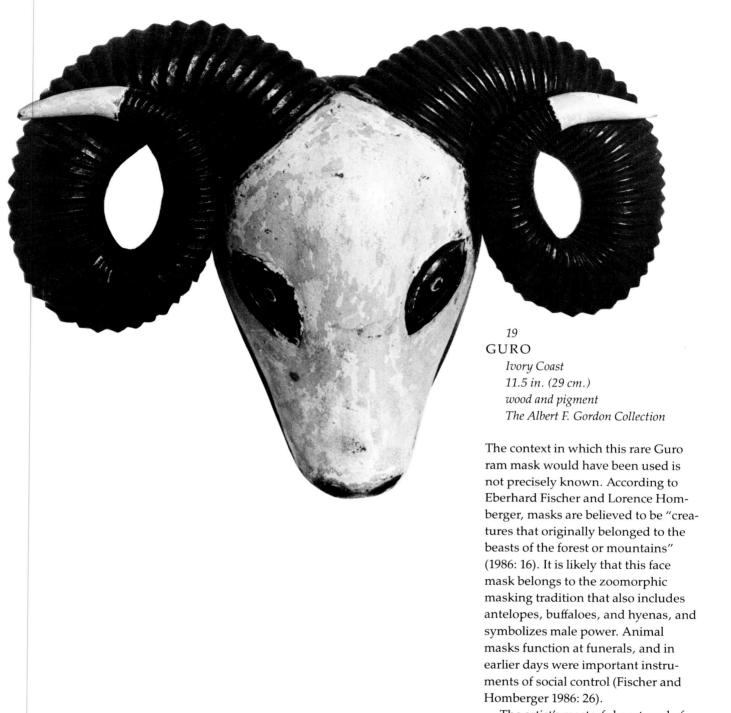

19
GURO
Ivory Coast
11.5 in. (29 cm.)
wood and pigment
The Albert F. Gordon Collection

The context in which this rare Guro ram mask would have been used is not precisely known. According to Eberhard Fischer and Lorence Homberger, masks are believed to be "creatures that originally belonged to the beasts of the forest or mountains" (1986: 16). It is likely that this face mask belongs to the zoomorphic masking tradition that also includes antelopes, buffaloes, and hyenas, and symbolizes male power. Animal masks function at funerals, and in earlier days were important instruments of social control (Fischer and Homberger 1986: 26).

The artist's masterful portrayal of naturalistic form is conveyed by this elegant mask. The tapered symmetrical face is pigmented with muted layers and hues of white. In sharp contrast is the lustrous jet-black patina of the elliptical eyes and the graceful curved horns.
– S.B.

20
BAULE
Ivory Coast
18 in. (46 cm.)
wood, pigment, shells, metal, cloth,
and beads
Williams College Museum of Art,
Museum purchase (75.13)

The Baule of central Ivory Coast have a number of divergent masking traditions, both in form and function. This work belongs to the category of portrait masks, which are primarily of beautiful women and are danced for entertainment (*gba gba*). Masks of this type are worn by men, but they must be accompanied by the woman portrayed. Precise physical resemblance is not a concern in African portraiture, and certain defining characteristics of either the mask, or its accompanying costume and accoutrements, serve to identify the subject of the portrait (Borgarti in Borgarti and Brilliant 1990: 45, 46; Evanoff in Cole 1985: 54, 56).

Unlike most traditional portrait masks, this example features the face of the mask carved within a squared panel. Colorful beads adorn the elaborate high coiffure and echo the beautiful wide-beaded border surrounding the face. Decorative metal brads are repeated around the eyes and mouth; indigo pigment emphasizes the idealized features and the incised coiffure. The woven costume attachment cascading down the back of the mask is decorated with cowries (a sign of wealth) and other shells.
– S.B.

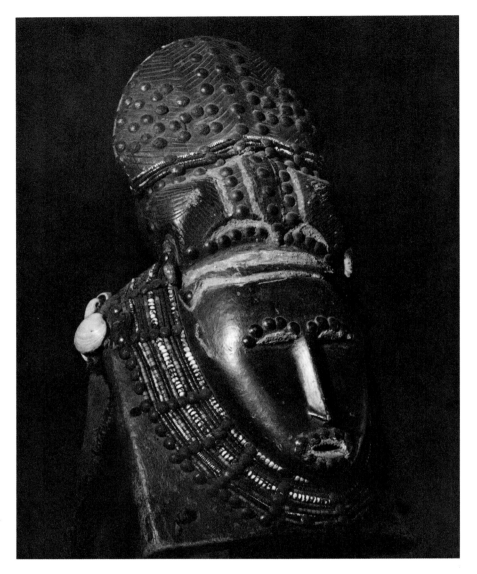

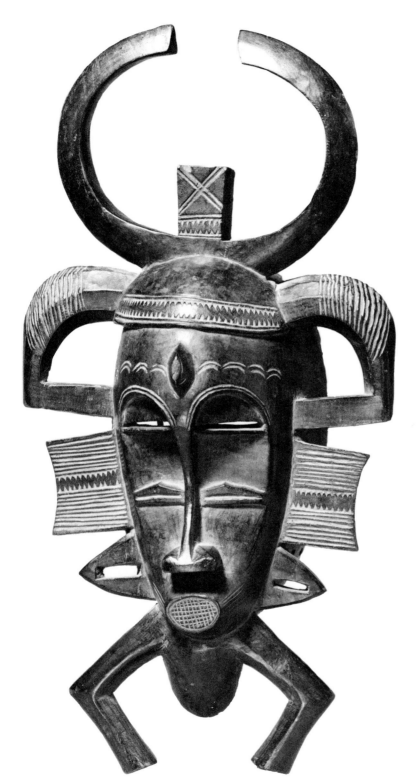

21
SENUFO
Ivory Coast
15 in. (38 cm.)
wood
*Mead Art Museum, Amherst College,
Gift of Barry D. Maurer, Class of
1959, in memory of his father, Myron
P. Maurer (1989.88)*

Although male authority is unquestioned in political and social spheres, the woman's role as mediator between the human and the supernatural world is paramount and reflects the important Senufo belief that male/ female balance is essential for the well-being and continuity of the village (Glaze 1975: 25-29; 1981: 46, 47). Commonly referred to in the literature by its French name, *Kpelie* (*Kpeli-yehe/ Kodoli-yehe* in Senufo), this type of mask represents a female component in male initiation ceremonies and in funeral rites. Worn by junior members of the blacksmith secret society (*Poro*), the dance movements combine both male and female qualities, and the mask "is always intended to 'be beautiful' in praise of a man or youth on the occasion of his commemorative funeral" (Glaze 1981: 127).

This stylized mask of the late 19th century features the traditional *Kpelie* pierced slit eyeholes, a protruding mouth, and incised linear scarification. Symmetrical decorative elements project from either side, and the mask is surmounted by hornlike projections. The lower extensions of the mask represent a traditional Senufo woman's hairstyle.
– S.B.

22
SENUFO
> *Ivory Coast*
> *22 in. (56 cm.)*
> *wood and metal*
> *Penelope Naylor Collection*

The male *Poro* society (*Lo* society) functions in harmony with the women's *Sandogo* society, providing the framework for every aspect of Senufo social, religious, and political life. A variant of the traditional *Kpelie* style (see #21), this mask would have been danced to celebrate important rites of passage. The power of the buffalo is evoked by the flat curved horns, imbuing the masked dancer with strength. The buffalo is an important iconographic element among different Senufo *Poro* societies, and its meaning varies from group to group. According to Anita Glaze, among some groups it symbolizes "advancement and regeneration in the *Poro* cycle, the path to adulthood and fulfillment" (In Vogel 1981: 41, 42).

The mask is carved in the earlier style of the Djimini region (Goldwater 1964: no. 37). The composed oval face has rounded contours, with downcast crescent-shaped eyeholes and a small round mouth. The coiffure projections, horns, cheeks, and eyelids are embellished with hammered brads, another feature that makes the Djimini style distinctive. A snake emblem is curled on the forehead, and horizontal scarification extends from both sides of the mouth.
– *S.B.*

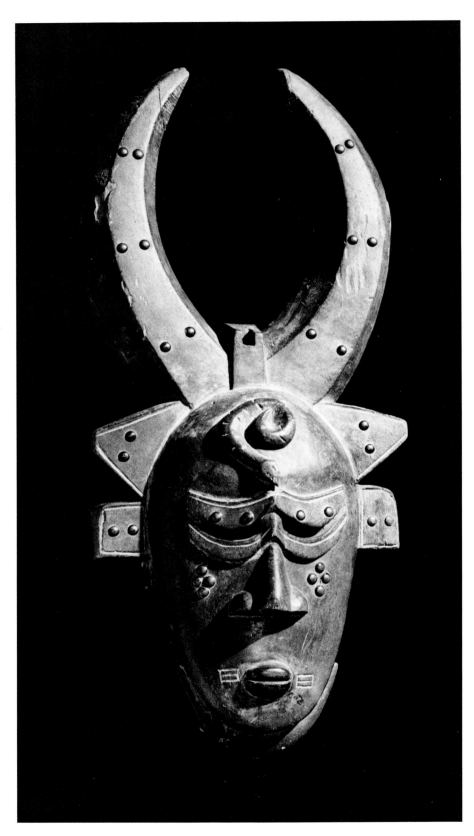

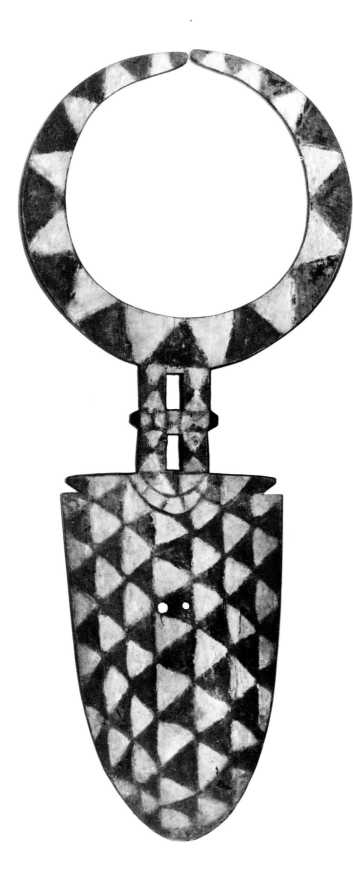

23
NAFANA
Ivory Coast/Ghana
63.75 in. (161 cm.)
wood and pigment
Williams College Museum of Art,
Museum purchase (74.4)

The tall abstract *Bedu* masquerade masks are among the monumental works of sub-Sahara Africa. Often over ten feet in height, the masks are danced during the Nafana lunar month, and appear nightly in rituals that involve the entire community. The paired male/female masks (the female superstructure is a solid disk) perform in the village common and also visit every individual dwelling before the month is over. The masks foster communal and family unity, purify the village and protect it from disasters, and are believed to possess exceptional curative powers. Based on an ancient pre-colonial masking cult, the modern form of the *Bedu* festival dates to the 1930s (Williams 1968: 18, 19; Bravmann in Vogel 1981: 30).

This imposing mask, carved in one piece, is entirely covered by painted black and white triangular designs. The lower shield-like portion has pierced eyeholes and is surmounted by tall curving horns forming an al- most perfect circle. The dancer would be entirely hidden by a raffia costume made of tree bark.
– S.B.

24
YORUBA
Nigeria
16 in. (41 cm.)
wood and pigment
The Graham Collection

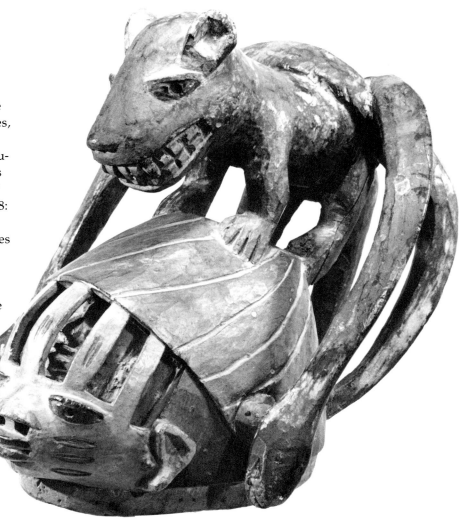

Gelede masquerades utilize elaborate wooden headdresses, cloth costumes, dances, songs, and drumming. The performances honor women, particularly older women who may possess extraordinary power rivaling that of the Gods and ancestors (Drewal 1978: 18). With this power, "the mothers" may help or hinder. The masquerades not only honor, they entertain, moralize, and criticize. A serene countenance is desirable, and the colors green and yellow are felt to be particularly appropriate (Drewal and Drewal 1983).

The gentle appearance of the outer face, with its vertical cutouts revealing another face carved within the forehead, suggests a reflection and echoing of inner calm. The superstructure, a leopard (symbol of royalty) surmounted by snakes (symbols of the earth), may indicate that the earth does not discriminate, and ultimately conquers.

The mask is carved from a single piece of wood, and the custom of repainting these masks before festival use has resulted in layers of multihued polychroming. Describing this mask, Henry Drewal wrote: "[it is] a wonderful piece, with intriguing imagery and a lively style. A similar piece is in the museum at Ibadan. I believe it was carved about 1923 by a carver named Adeleke" (1983: personal communication).

– G.G.

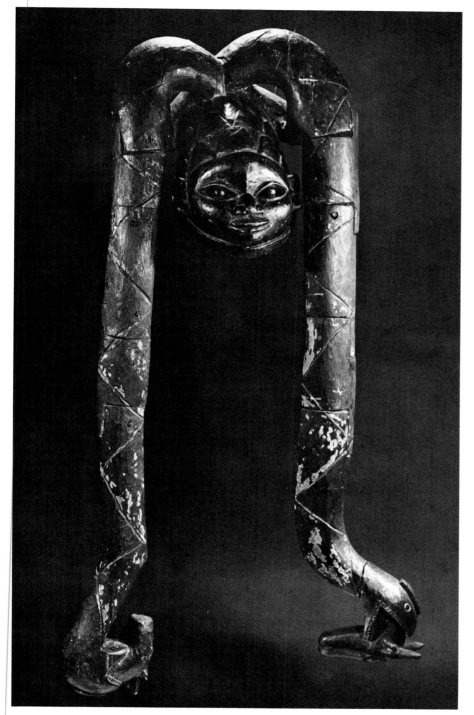

25
YORUBA
Nigeria
42 in. (107 cm.)
wood and pigment
The Graham Collection

Danced in identical pairs, *Gelede* masks may relate to the frequent birth of twins among the Yoruba. Twins are felt to share one soul, and therefore this masquerade cannot be complete with only one mask. The dance honors women, especially older ones called "our mothers," many of whom would have borne twins. The dance comments on social concerns, desires, and proprieties. The snake, symbol of earth to which we all return (therefore also, in a sense, a symbol of death), is often depicted in *Gelede* masks. The transitory nature of existence in the world is expressed in the Yoruba proverb: "The world is a market, the other-world is home"; we only briefly visit the market, but we live at home (Drewal and Drewal 1983: 1,2).

This mask, with its long articulated snakes devouring antelopes, suggests the evanescent nature of all life; the snake (earth) is reclaiming this large animal. A dancer would grasp the snakes near the head and move them about during performance. The head portion of this mask was carved by Fagbite Asamu of Idahin, circa 1930, and the snake attachments were finished in 1971 by his son and student Faola Edun after Fagbite's death (Drewal and Drewal 1983:159). (Field photograph: Drewal and Drewal 1975: 37; 1983: 160.)
– G.G.

26
YORUBA
Nigeria
23.5 in. (60 cm.)
wood and pigment
The Graham Collection

Existence is influenced by forces seen and unseen, natural and supernatural: powerful elders, ancestors, spirits, and deities. Masks reconnect these worlds. Used in a nocturnal masquerade, this *Efel Gelede* headdress gives substance to the unseen spirit world (Drewal and Drewal 1983: 85-95).

This example, called *Apasa*, displays the prominent striped ears, broad flat banded beard, and scarified face typical of this form (Drewal 1980: 74). Polychromed in red, white, and black, it would have been worn with a full costume and the masker's face covered with cloth.

– G.G.

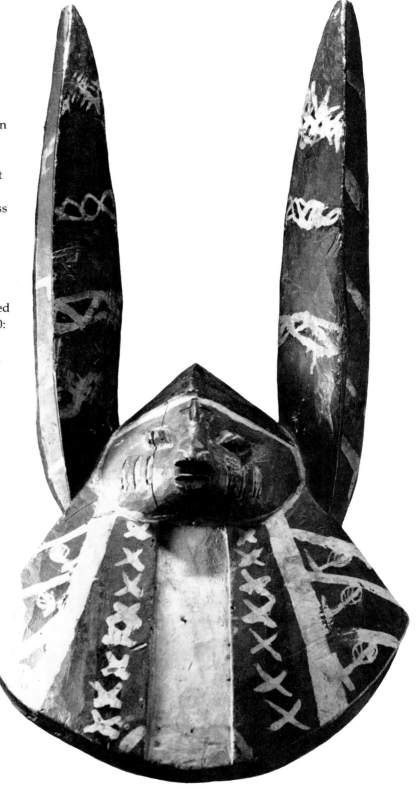

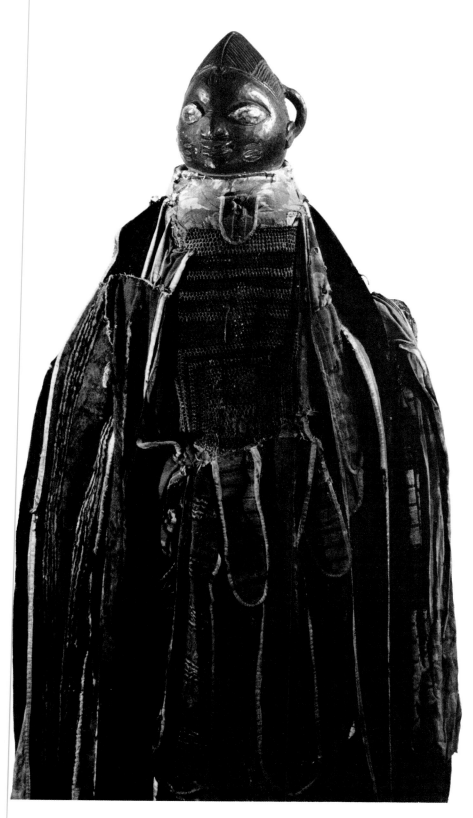

27
YORUBA
Nigeria
11.5 in. (29 cm.) mask only
wood, cloth, and pigment
The Graham Collection

In diverse masquerades called *Egun-gun* honoring the spirit of the ancestors, "cloth, a primary means of materializing such forces, is often combined with elaborately sculptured wooden headdresses" (Drewal 1980: 77). The fact that "the spirits of hunters who return in the form of such masks use the left hand in ritual greeting" (Thompson 1970: 15/2) may be reflected in this mask. Springing from the left side of the head, behind the ear, is a small arm and hand—the hunter's greeting.

The blackened headdress, with protruding white eyes and horizontal cheek scarification, is worn atop the head of the dancer who sees through a wide-woven screen. This example still has the costume, an integral part of all masking traditions. (Illustrated: Borgatti, Brilliant, and Wardell 1990: 88.)
– G.G.

28
YORUBA
Nigeria
9.5 in. (24 cm.)
wood
The Albert F. Gordon Collection

Egungun means "powers concealed," and the rituals associated with the annual festivals invoking the protective powers of lineage ancestors are often performed over a period of several weeks and involve the entire community (Pemberton in Drewal, Pemberton III, and Abiodun 1989: 175). This carved wood headdress would have been worn with an elaborate costume of many layers of appliquéd colored cloth strips concealing the dancer. The elongated slightly pointed ears may refer to a traditional *Egungun* image of the hare, symbolically endowing the mask with supernatural hearing powers.

The headdress has a rich brown patina and features traditional elliptical Yoruba eyes and parallel lips. Vertical triscarification is incised into each cheek. The intricate coiffure is surmounted by an openwork crest, possibly a variant of the cockscomb, *agogo*-style (Drewal 1980: 83).
– S.B.

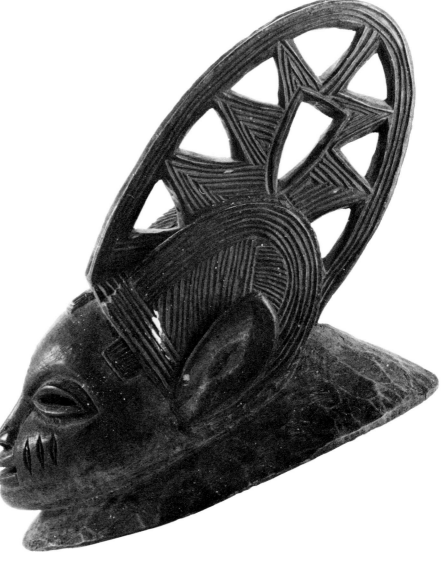

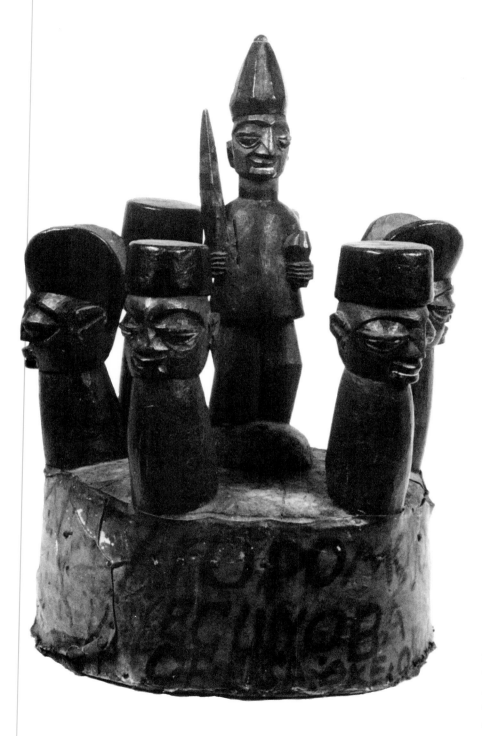

29
YORUBA
Nigeria
18 in. (46 cm.)
wood, pigment, and hide
Mead Art Museum, Amherst College,
Gift of Robert and Suzanne Bach
(1985.3)

Ancestors are considered "living dead," whose powers to affect the lives in the world of the living is channeled through elaborate commemorative performances called *Egungun* (Pemberton in Drewal, Pemberton III, and Abiodun 1989: 175-187). These supernatural powers are manifested throughout Yorubaland in an astounding variety of masks. According to John Pemberton of Amherst College, this headdress is from the northwestern Ogbomina/Ekiti area and features a central figure of authority, possibly a reference to a particular or collective ancestor. Four male heads with Islamic style hats and two female heads with the traditional Yoruba divided coiffure surround the main figure (Pemberton 1991: personal communication).

The central power figure holds a sword (physical power) and a gourd (inner power) containing protective and therapeutic ingredients. Cloths of assorted colors would have been looped around each neck, cascading down and covering the attributive name written on the hide portion of the mask. The netting concealing the face might have been crowned in cowries (Pemberton 1991: personal communication).
– S.B.

30
IGBO
Nigeria
15 in. (38 cm.)
wood, pigment, raffia, and cloth
The Albert F. Gordon Collection

The spiritual beauty of female ancestors is manifested in this *Mmuo* "maiden spirit" headdress. "Beauty" masks originally functioned in opposition to destructive "beast" masks by promoting positive societal values, appearing at funerals, and propitiating beneficent deities (Blier 1976). The well-being of the community could be ensured by restoring the equilibrium of the opposing forces of nature.

Herbert Cole and Chike Aniakor describe and illustrate the colorful and entertaining annual festivals in which these "maiden spirit" masks appear today in the northcentral Igbo region. Numerous *Mmuo* dancers (men) wearing appliquéd costumes mime quintessential female motions that personify the desirable attributes of serenity, purity, and grace. The entire community attends the spectacle, which includes elaborate sequences to the accompaniment of an orchestra and chorus singers. The festival entertains while it celebrates various aspects of femininity and fertility, and pays homage to the ancestors (Cole and Aniakor 1984: 120-128).

This classic headdress exhibits idealized thin features, emphasized by glossy black pigments in contrast to the white surface. An elaborate raffia coiffure is plaited in swirling patterns and has four attached braids. A portion of the original cloth dance costume is still attached to the helmet. (Illustrated: Larsen 1979: no. 126.)
– S.B.

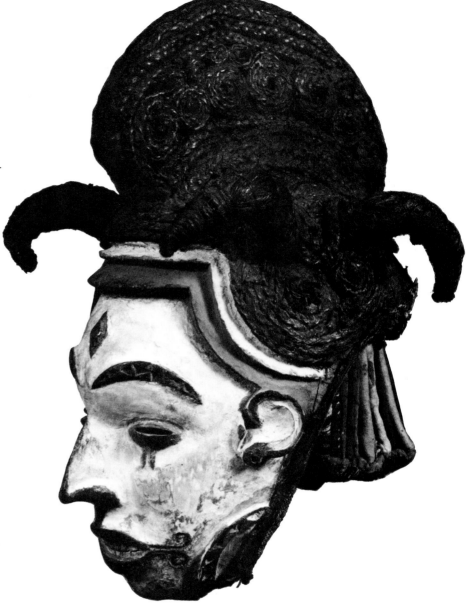

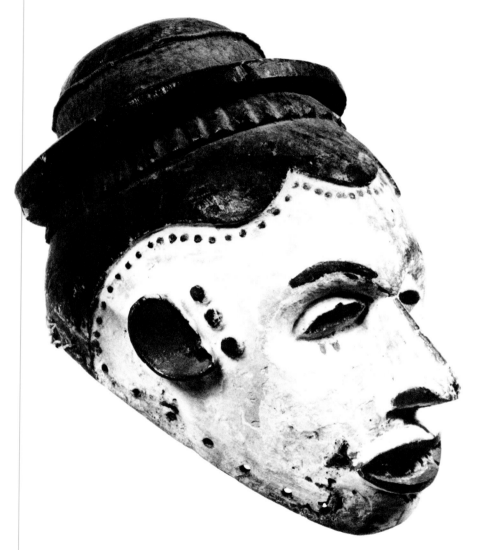

31
IGBO
Nigeria
12.5 in. (32 cm.)
wood, pigment, and cloth
Collection of Robert and Suzanne Bach

Although satirical generic portraits of white colonial men were a common masquerade theme, in this instance the Western-style derby hat of the mask likely reflects positive concepts of status and authority. Herbert Cole states that the style corresponds to that of the Ngwo village group of the northern Igbo region (1989: personal communication). Danced at funerals, many of these older masks were "re-tired" in the sixties, and replaced by new modern carvings painted in enamels (Starkweather 1968: nos. 125, 126). The helmet exhibits the traditional aesthetic characteristics of the male counterpart of the *Mmuo* "beauty" masks (see #30).

The well-proportioned head features almond-shaped eyes, a long straight nose, and a parted thin-lipped mouth. The white kaolin surface evokes the spirit world of the ancestors and contrasts sharply with the black and red pigments of the prominent ears, coiffure, hat, and scarification patterns. A red cloth band adorns the hat.
– S.B.

32
IGBO
Nigeria
33 in. (84 cm.)
wood and pigment
The Albert F. Gordon Collection

This horned *Mgbedike* helmet mask embodies the spiritual power and potent male forces necessary to rid the community of harmful spirits. Throughout the Niger Delta region, horns symbolize virility and supernatural strength. This power imagery is echoed by the male figure that clasps the horns and whose controlled stance is similar to that of protective *Ikenga* statues. Today, *Mgbedike* maskers are important titled men of middle age considered to possess both physical and spiritual strength. In earlier times, these spirit masks would have been danced by warriors (Cole and Aniakor 1984: 131, 132). A voluminous costume completes the awesome effect by giving the dancer superhuman size. *Mgbedike* masqueraders perform energetic feats of agility and endurance during agricultural festivals and burial celebrations.

The aura of power is created by the dark patina, bold facial planes, and exaggerated features including the large jagged-toothed mouth. This particular *Mgbedike* helmet is surmounted by two pairs of horns: curved horns projecting forward from the crown and upswept bush spirit horns embellished with rows of incised scarification.
— S.B.

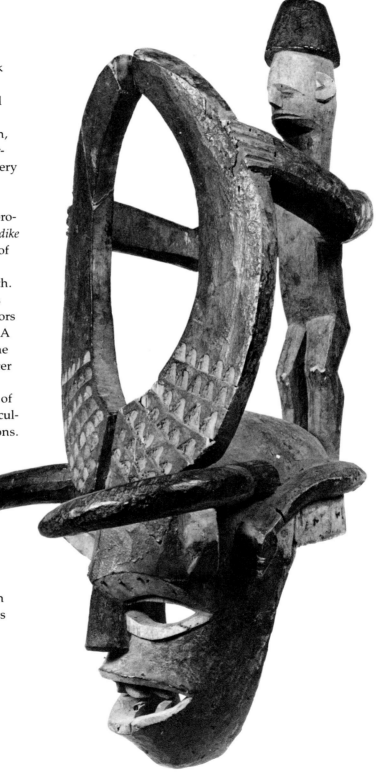

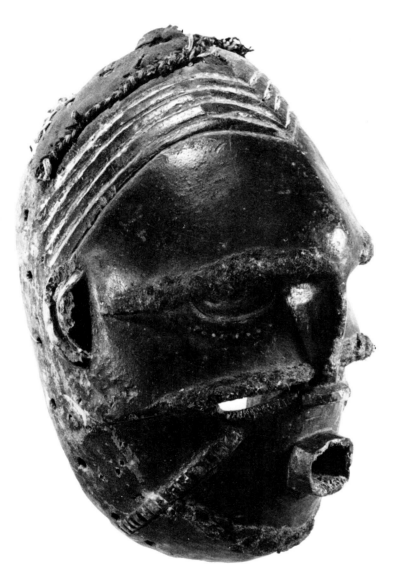

33
IGBO
Nigeria
14.5 in. (37 cm.)
wood, cloth, hair, and pigment
The Graham Collection

This mask comes from the northeast corner of Igboland just north of the Cross River. Spirit masks called *Ogbodo* still appear regularly in masquerades, although many old masks were destroyed during the 1967-70 civil war. This unusual mask was carved by the Ezzamgbo (Cole 1991: personal communication), one of the small groups of the region whose dialect and culture set it apart from the central southern Igbo. With his hands and feet marked with white chalk to indicate the presence of the spirit within, the masked costumed dancer is empowered to perform the traditional movements (Weston in Cole 1984: 145).

This black mask features prominent brows overhanging crescent-shaped blind eyes. The actual eyeholes lie below the hair-covered cheek bones, and scarification marks extend on either side of a rectangular protruding mouth.
– G.G.

34
IGBO
Nigeria
9.5 in. (24 cm.)
wood, pigment, and raffia
The Albert F. Gordon Collection

The *Nnade Okumkpa* ("father of the *Okumkpa* play") mask is worn by one of the leaders of Afikpo masquerades and performs in satiric plays during the dry season. Various dances and plays are particular to each village, and have been detailed extensively by Simon Ottenberg and Frank Starkweather. According to Ottenberg, this rare mask of an ancient design could be attributed to the Ego, who preceded the Afikpo in the Cross River region (1991: personal communication; 1975: 39). Unlike later *Okumkpa* styles, older masks evoked fear because they were believed to possess great powers. These diminutive wood masks would be attached to a plaited raffia band that projects the mask forward from the dancer's face (Ottenberg 1975: 36-39; Starkweather 1968).

Harlequin patterned pigments in black, white, red-orange, and yellow emphasize the abstract geometry of this mask. The overall yam-shaped face has slightly convex contours angling back from a medial ridge that only suggests a nose. In contrast, both the forehead and the triangular chin are flattened planes. The oval eyes meet at the center, and each cheek has an incised starburst pattern.
– S.B.

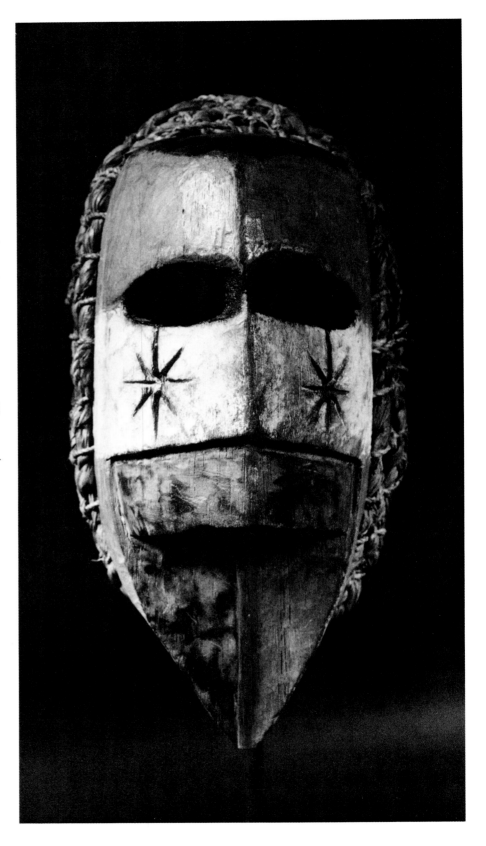

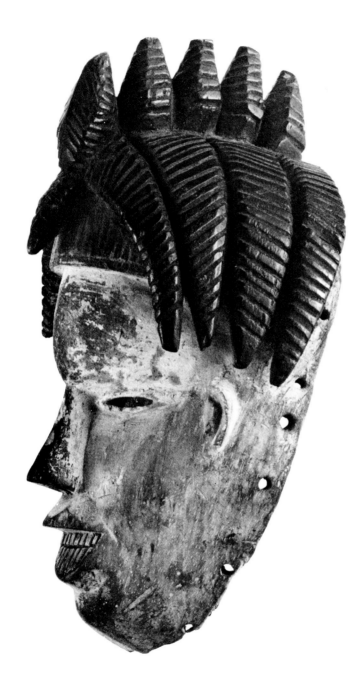

35
IGBO
Nigeria
9 in. (23 cm.)
wood and pigment
The Albert F. Gordon Collection

One of the most important ritual masquerades among the southwestern Igbo is the *Okoroshi* (or *Okorosia*), performed during the rainy season when water spirits are believed to visit the earth. Small and delicate white female masks called *Okoroshi Oma* represent positive values and dance in opposition to *Okoroshi Ojo*, dark and often distorted masks (Cole and Aniakor 1984: 186-199). The visual polarity evident in the masks and accoutrements of the dancers is emphasized by their movements as well as by their attributed individual names. A female "beauty" mask might be called "breath of wind," while a "beast" mask might be named "vampire" (Blier 1976: 7). The slow graceful dance movements of the "beauty" mask provide a vivid contrast to the erratic forceful motions of the opposing "beast" mask representing discord and malevolence. (See also #36-39 on *Okoroshi* masks.)

The refined facial features and the parted mouth with rows of evenly spaced teeth are characteristic of *Okoroshi Oma*. Repeated applications of white kaolin clay, indicating ancestral linkage, have been worn away leaving a porcelain-like patina. The glossy black tripartite coiffure has elaborate rows of incised curls.
– S.B.

36-39
IGBO *OKOROSHI* MASQUERADES
Nigeria
Collection of Mr. and Mrs. Herbert
M. Cole

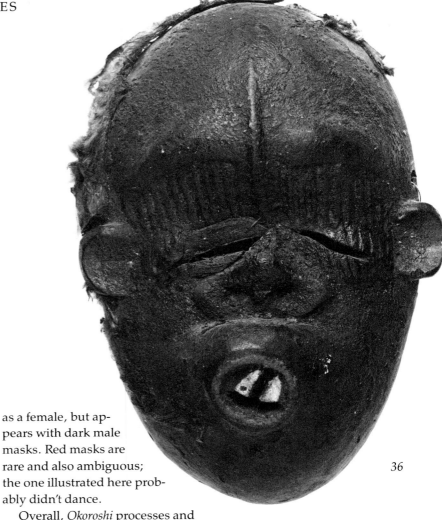

36

These four *Okoroshi* masks are among dozens of water spirit (*owu*) characters that danced for six weeks in southwestern Igboland during the height of the rainy season. The masking cult's primary stated purpose is to promote agricultural and human fertility; the day after these spirits return to their "homes in the clouds," New Yam—the annual first fruits festival—is celebrated. Spirit characters are numerous and varied; as many as a hundred came out in Mgbala Agwa in 1983, and probably more have since then. Local Igbo divide the characters into two classes: evil, dark or ugly-faced males, *Okoroshi Ojo*, in contrast to pretty, delicate-featured, white-faced females, *Okoroshi Oma*. These masks are associated with a self-conscious dualistic model in Igbo thought: binary oppositions that include night vs. day, obscure/mysterious vs. clear, bush vs. village, among others. Yet the full range of spirit characters is actually a continuum, ranging from the benign white masks that dance in large arenas to entertain (and make money) to a few charm-laden dark "heavy" masks accompanied by hundreds of club-carrying male supporters —a kind of militia. Three or four of the strongest of these dark spirits that emerge at the end of the *Okoroshi* season are, above all, expressions of power. Despite classes of light and dark masks, the emphasis is on shades of gray, on ambiguity and even contradiction. The white mask in this group, for example, is classed as a female, but appears with dark male masks. Red masks are rare and also ambiguous; the one illustrated here probably didn't dance.

Overall, *Okoroshi* processes and spirit characters seem to represent much of the complexity and uncertainty of human life. The fact that dark masks outnumber white ones by an 8- or 10-to-1 ratio suggests that people in this area view life as difficult and oppressive far more than they see it as joyful. Women, who are said to have brought this form of masking into the area, are idealized in some of the white-faced masks. The emotional and psychological dimensions of men creating ugly, if powerful, masks for themselves are yet to be fully understood.

– Herbert M. Cole

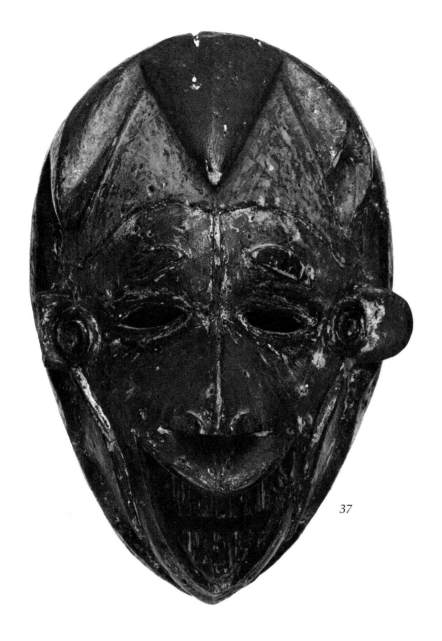

37

36 (far left)
10 in. (25 cm.)
wood, pigment, iron nails, and
animal hide

This suppressor mask, *Omewuoha* (*Okoroshi Ojo*), was carved by Anozie of Mgbala Agwa ca. 1955, and acquired from his family in 1983. It began as a "small" male mask (*Ojo*), but increased rapidly to become a feared "big" mask because it harassed and beat everyone it came across, regardless of gender or status. An example of mobility, it stopped appearing ca. 1977, when its inventor became too old to dance. This mask is possiibly a replacement for the original one.

This black mask has a deliberately misshapen face, the mouth projecting outward and showing two teeth within constricted red circular lips. Tab ears extend laterally beside the eyes, which are slanted slits (one of which was repaired in Agwa following rat-chewing damage). There is simulated vertical scarification on and above the eyelids. Animal fur, which partly remains, once surrounded the face.

37 (left)
9 in. (23 cm.)
wood and pigment

The herald mask, *Olo*, (or possibly the first son of sons mask, *Nwadum*) (*Okoroshi Ojo*) was carved in Agwa ca. 1950. This especially ambiguous mask, as indicated by its dominant *(continued next page)*

(*continued from previous page*)
red color, is carved in the fine-featured
style of feminine examples, yet is
considered a male spirit. Worn by one
of the *Owu* cult leaders outside of
normal patterns—principally to levy
fines, the mask has not appeared
since ca. 1965-66.

This is a quite typical symmetrical
fine-featured female mask, painted
red rather than the usual white. The
details were originally emphasized
with black, and later partially with
bright green. The eyes and mouth are
rendered open. Target-like concentric
circles between the eyes and the tab
ears (one of which is partly broken)
represent scarification. The eyebrows
are crescents in high relief. A three-
lobed hairstyle over the forehead is
echoed along the jaw line by a scal-
loped ridge.

> *38 (right)*
> *9.5 in. (24 cm.)*
> *wood and smoke patina*

This kingfisher mask, *Nkelu* (*Okoroshi
Ojo*), was carved by Anozie of Mgbala
Agwa ca. 1945, and acquired from his
family in 1983. It is a male mask of
medium-range power. Kingfishers
(the birds) are considered potent and
mysterious, and parts of them are
used with other ingredients to make
charms and medicines.

Combined bird and human, this
symmetrical oval mask has a human
nose below which begins a long
downward curving beak, partly open
and revealing teeth. The eyes slant
downward from the nose bridge, and

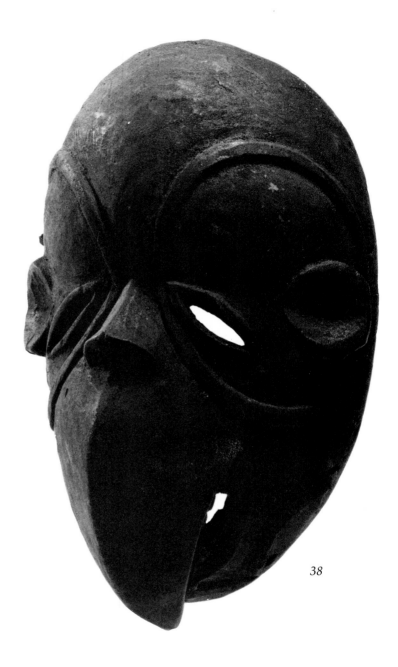

38

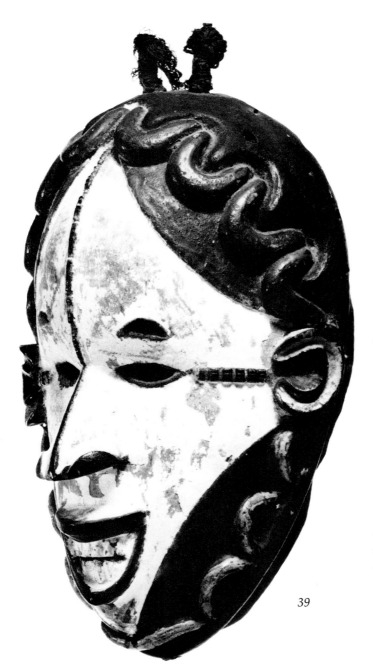

39

the eyes and semicircular ears are enclosed within a large semicircular relief line that divides the face into three zones.

39 (left)
9 in. (23 cm.)
wood, pigment, iron nails, and yarn

This "leopard imitator" mask, *Onyen-jeagu (Okoroshi Oma)*, was made in Mgbala Agwa ca. 1920-25. It is delicately carved with fine symmetrical features bordered in black in contrast to the central white facial area. The diamond-shaped white area is quartered by a broken vertical line bisecting the face and a horizontal line formed by the eyes and the lateral scars beside them. The outer edges of the white area are defined by four semicircular quadrants, each further detailed with borders of linked crescents in high relief.
– H.M.C.

40

IBIBIO

Nigeria
20 in. (51 cm.)
wood and pigment
The Albert F. Gordon Collection

The primary social control cult among the Ibibio of the Cross River region is the powerful *Ekpo* society. Elaborate masquerades are performed to evoke ancestral blessings for the welfare of the community and to maintain order. Ancestral ghosts, both good (*Mfon Ekpo*) and evil (*Idiok Ekpo*) are believed to visit the earth and affect the lives of their descendants. This triple-faced *Idiok Ekpo* "beast" mask represents a potentially threatening spirit, and its performance would dramatize brute strength and discord with vigorous, unpredictable swirling motions, in direct contrast to the controlled movements of the "beauty" masks (Blier 1976: 6-9).

Expressive features include circular sunken and double-lidded eyes, an articulated jaw, and thick everted lips. The encrusted black patina, always the dominant color in "beast" masks, is accentuated with red and blue pigments that further enhance the mask's effect.
— S.B.

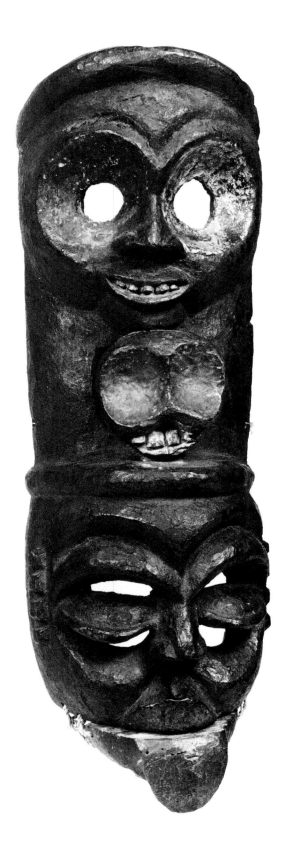

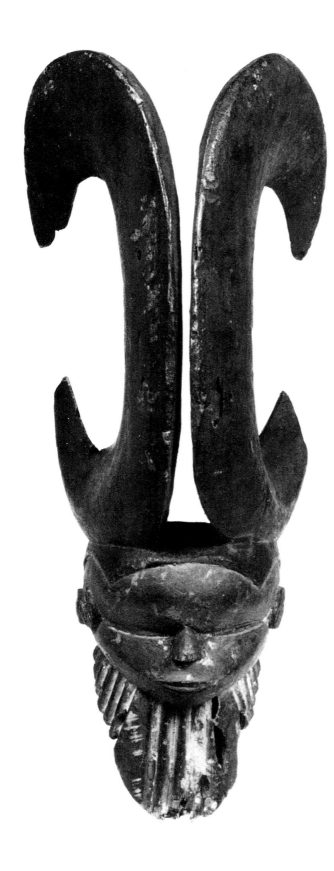

41
EKET (?)
Nigeria
11.5 in. (29 cm.)
wood and pigment
The Albert F. Gordon Collection

While the Eket of southeastern Nigeria carve numerous face masks and headdresses for agricultural and funeral ceremonies, the context in which this rare crest would have appeared is not known. Characterized by a unique synthesis of composition and design, the crest would likely have been worn on the forehead lashed to a basketry cap.

The facial features are reduced to essentials with the rounded forehead and wedge-shaped lower face joining to form elongated eyes. The extended neck ruff is incised with vertical grooves containing traces of white kaolin. The soft red sheen of the face contrasts beautifully with the black patina of the sweeping horns that dominate the crest.
– S.B.

42
EKET
Nigeria
15.5 in. (40 cm.)
wood
The Graham Collection

Among the neighboring Igbo, *Ogbom* headcrests functioned in rituals that honor the earth and her role in agricultural and human fertility. This Eket headdress may have had similar functions and was worn attached to a basketry cap on the head of the dancer, who would have been hidden under a colorful costume (Cole and Aniakor 1984: 174).

The crowning head of this tri-faced dance crest is distinctly ovoid with a concave facial plane. The minimal features include cowrie-shaped eyes on either side of the spatulate nose and a small horizontal line in the jaw to indicate the mouth. The ears accentuate the facial scarification, and the ringed neck leads down to two deeply carved bas-relief masks facing different directions.

– G.G.

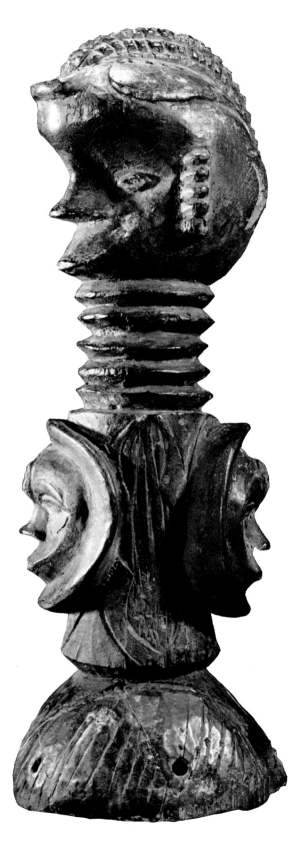

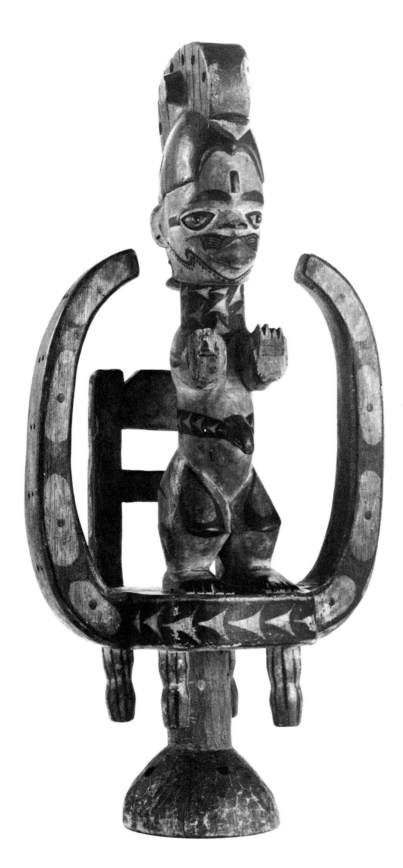

43
OGONI / IBIBIO (?)
Nigeria
18.5 in. (47 cm.)
wood and pigment
The Albert F. Gordon Collection

Although related to Igbo *Ogbom* and Eket dance headdresses that depict seated or standing female figures, precise attribution of this beautiful crest is problematic. Facial characteristics approximate Ogoni features (Cole 1991: personal communication), yet this style of headdress is not a known part of their masking tradition. A sculpture with similar attributes, but not identified, appears in W.O. Oldman's *Catalogue of Ethnographic Specimens* (1908).

The position of the figure on a Western-style seat may indicate high rank, while power is evoked by the curved horns. Stability is expressed by the taut flexed stance of the figure, and the rounded contours and facial features evoke the essence of female beauty. The elaborate painted patterns encircling her neck and waist may refer to wealth, and the palms-up gesture, to honor and devotion. The deep surface patina has traces of white kaolin and glossy black pigments.
– S.B.

44
OGONI
Nigeria
11.5 in. (29 cm.)
wood and pigment
The Albert F. Gordon Collection

This unusual Ogoni dance mask is a highly abstracted version of the *Karikpo* antelope mask. Reverence for the antelope forest spirit is indicated by the curved horns, symbolizing virility and power. These masks would have been worn in impressive athletic dances displaying prowess and strength at seasonal masquerades and harvest celebrations (see #45).

The Ogoni use vivid colors on their sculpture, but only traces of red pigment remain on the deeply patinated surface of this mask. The diamond-shaped face is divided into two triangles by a long rectangular nose, a protruding mouth, and an X-shaped forehead emblem. Triangular eyeholes further emphasize the expressive angles of the mask.
– *S.B.*

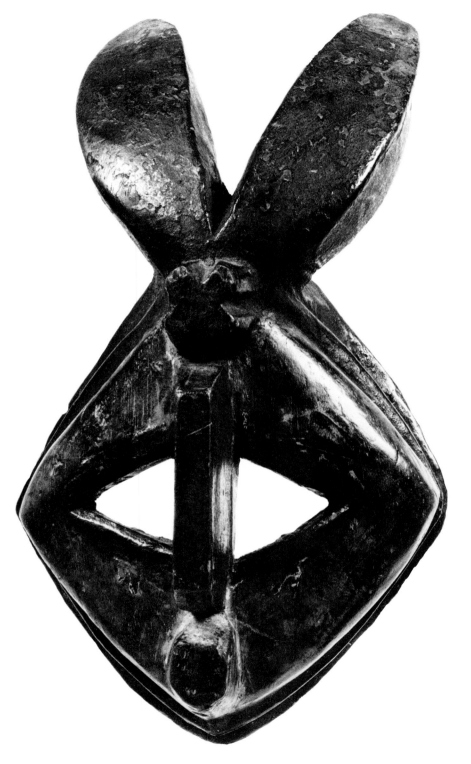

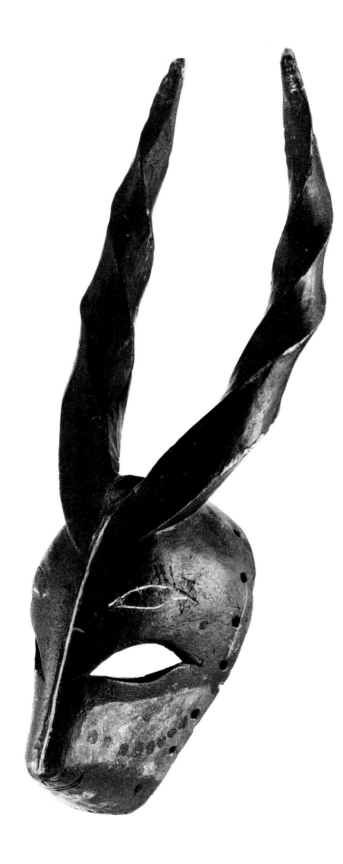

45
OGONI
Nigeria
21 in. (53 cm.)
wood and pigment
The Albert F. Gordon Collection

The Ogoni have numerous men's masking societies that function on many levels: social, religious, and political (Murray as cited in Celenko 1983: 146). *Karikpo* antelope masks, worn in rituals honoring local founding ancestors during the agricultural cycle, incorporate racing darting movements and acrobatics to mimic the antelope's agility and cleverness. For the Ogoni, as for other peoples in the Cross River region, the horned antelope is a supernatural being of strength and virility (Wittmer and Arnett 1978: 48; Scheinberg 1975: 27).

This *Karikpo* mask epitomizes the refined Ogoni style. The elegant elongated face is surmounted by sweeping twisted horns. The almond-shaped eyes and slightly concave facial planes are highlighted with subtle remnants of deep orange-red pigments over the black surface patina.
– S.B.

46
URHOBO
Nigeria
12.5 in. (32 cm.)
wood and pigment
The Albert F. Gordon Collection

Situated in the Niger River Delta, the Urhobo pay homage to the powerful water spirit *Ohworu* in elaborate rituals and festivals. According to Perkins Foss, honoring both water and forest spirits is central to Urhobo religious practice, and is considered essential for the well-being of the community. *Ohworu* is particularly sacred to women, and the spiritual beauty of her accompanying water spirits is emulated by *Ohworu* society dancers, who are transformed by carved wood masks, billowing white robes, and multicolored scarves. Water spirit masks such as this one are believed to be beneficent and to embody the essence of young womanhood (Foss 1973: 20-27; in Vogel 1981: 146).

The composed oval face has semicircular lidded eyes, a small nose, and parted lips revealing rows of teeth. Forehead scarification of elongated vertical incised lines is enhanced with blue, purple, and white pigments. The neck handle, used to hold the mask during the dance, is well patinated.
– S.B.

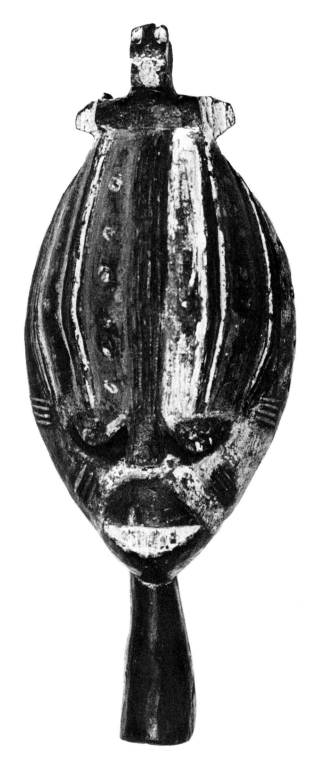

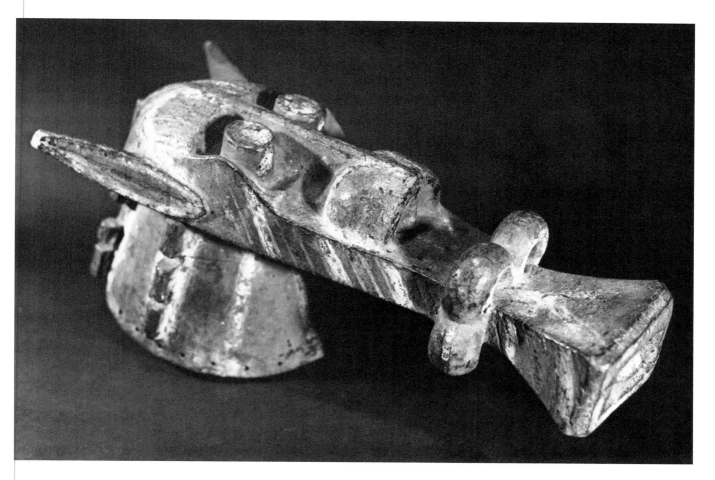

47
IJO
Nigeria
21 in. (54 cm.) (length)
wood and pigment
The Graham Collection

The Ijo are a riverine people who believe that they share the environment with supernatural beings called Water People. This water spirit mask, worn horizontally on top of the head, faced the sky and performed for both spirits and men. The masquerade often ended with the dancers entering and seeming to disappear into the water. Water spirits are thought to have a preference for the color white, which may account for the whitened areas on this mask (Anderson and Kreamer 1989: 112).

The headdress is an abstract hippopotamus with a long rectangular trumpet-shaped mouth. The rounded forehead continues into a narrow ridge-like nose bridge to end in flared nostrils. The narrowed portion of the snout supports four large pierced rings forming an encircling coverleaf. (Illustrated: Anderson and Kreamer 1989: 112.)
– G.G.

48
IDOMA
Nigeria
14 in. (36 cm.)
wood and pigment
The Albert F. Gordon Collection

Intercultural and artistic exchange is especially evident in the Benue and Cross River area of southeastern Nigeria. This particular crest style is carved by several of the Idoma neighbors, including the Igbo and the Ibibio. The *Ungulali* mask derives its name from the flute, one of the instruments played to accompany the dance. Traditionally worn at funerals and for purposes of social control, most Idoma masks today have been secularized and are used primarily for entertainment (Sieber in Vogel 1981: 165). The crest may personify the idealized woman, and the ancestral powers evoked were thought to be doubled by the additional head surmounting the headdress (Scheinberg 1976).

The refined faces convey composure and control. Each rounded head has a protruding forehead and concave cheeks forming a horizontal indentation for elongated eyes. The black outline of the features contrast with the well-worn white surface patina. The coiffure of the main head is pigmented black and red and embellished with attached curved horns and discs. The crest would have been secured to a basketry cap and worn on top of the head.
– S.B.

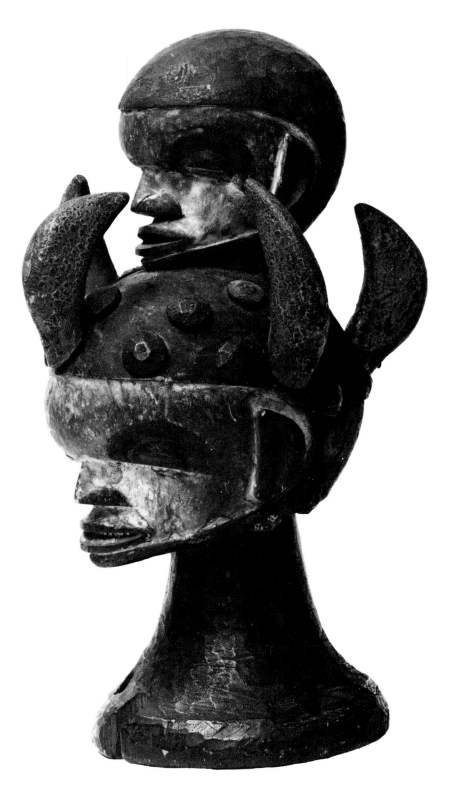

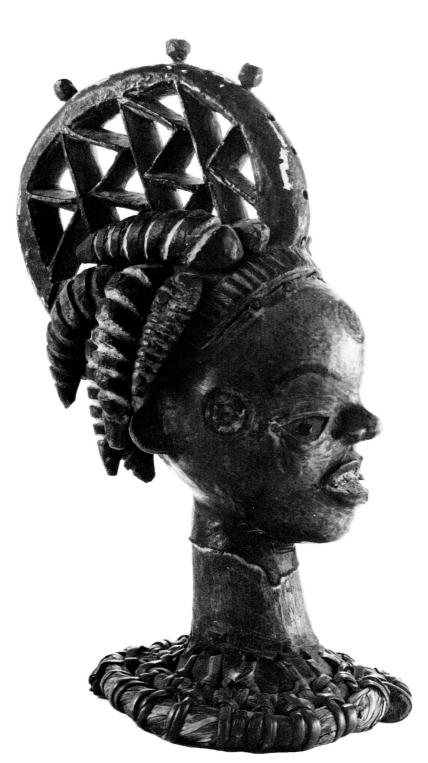

49
CROSS RIVER: EJAGHAM
Nigeria
13 in. (33 cm.)
wood, animal hide, and metal
The Albert F. Gordon Collection

Skin-covered headdresses, some of striking realism, are carved throughout the Cross River region of Nigeria and Cameroon. These crests, or "cap" masks, were commissioned and owned by a variety of powerful associations. Some of these societies "were limited to those who had slain a man in battle or had killed a leopard; others were associations of hunters" (Nicklin 1974: 15). According to the 1912 accounts of P. Amaury Talbot, the heads of slain enemies were originally used in dance rituals until this custom was banned in the early part of this century. The masks were danced at initiation rituals and important funerals, as well as secular celebrations. Today, many of the societies that would have commissioned these masks have abandoned their traditional functions. Keith Nicklin reports that although masks are still used at funerals, skin-covered masks are now appearing at special displays organized by state cultural organizations (1974: 12-15, 67, 68).

The well-defined features of this headdress are covered with light brown skin, the color for females. Wet antelope or goat hide would be stretched and pegged over the carved wood, tightening to the contours during the drying process. One interpretation holds that the skin itself is imbued with spirit forces from the past (Thompson 1981: 176). The elaborate openwork crested coiffure has attached wood "curls," and various pigments accentuate the incised patterns.
– *S.B.*

50
CHAMBA
Nigeria
27 in. (69 cm.) (length)
wood and pigment
Collection of Dr. Jonathan
and Lois Stolzenberg

The untamed power and strength of the male bush-cow spirit is embodied in this zoomorphic headdress. Stylized bush-cow (or Cape buffalo) masks are part of the masking tradition among several groups in the Benue River Valley. Arnold Rubin photographed an almost identical mask danced at an important Chamba funeral in 1965, and he underlines the fact that the style appears unchanged since these masks were first documented at the beginning of the century (in Fry 1978: 55, 56). Worn horizontally with a voluminous tiered fiber costume, the masquerader evokes the power and aggressive nature of the animal through his movements (Drewal 1977: 51).

Circular horns curve back from the massive domed forehead, and projecting rectangular jaws conceal the opening through which the dancer sees. Although one reference states that such masks would be danced in male and female pairs, black and red respectively (Roy 1979: 58), this particular mask may combine this tradition of duality with its distinctive half-black, half-red pigmentation divided by a line of white kaolin.
– S.B.

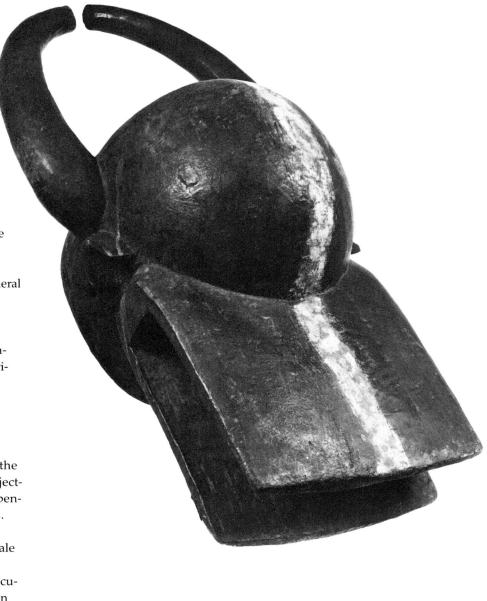

51
KINGDOM OF OKU
Cameroon
16 in. (40 cm.)
wood and pigment
The Graham Collection

Many Cameroon kingdoms have masking regulatory societies that maintain social control and traditional values. Responsibilities range from the regulation of cooking fires to the punishment of capital offenses. This lineage mask comes from the Kingdom of Oku and was called *Nkea*. It would precede members of the masking society, warn of their approach, and enforce proper behavior. Wearing a feather cloak, the masquerader brandishes spears and emits high-pitched sounds. The mask also participates in the night burial of masking lineage society members (Drewal 1988: 18, 19; Northern 1984: 66).

This powerfully carved mask with human-simian features has an open mouth with interlocking teeth. The mask is surmounted by three leopards, symbols of royalty. The swelling volumes and polished, yet rough, texture of the mask seem to create a feeling of both physical and spiritual power. (Illustrated: Anderson and Kreamer 1989: 144; Drewal 1988: 18.) – G.G.

52
KINGDOM OF OKU
Cameroon
18 in. (46 cm.)
wood and pigment
The Graham Collection

Masks are owned by the *Kwifoyn* regulatory society as well as by important lineages, although only "licensed" or authorized for use by *Kwifoyn*. Conducting their missions during the dark of night or hidden behind the masks, members of *Kwifoyn* ensure social control and law enforcement (Northern 1986: 44). Such masks are worn on top of the head with the wearer concealed behind a semitransparent cloth. This mask is a lineage mask from the Kindgom of Oku and was called *Ktam*. It personifies the spirit of a goat, an important sacrificial animal. The elaboration of the knobs is similar to the form seen in prestige hats. This mask and the female mask in the exhibition (see #53 and photograph on p. 13) were carved and owned by Fai Mankó, to whose lineage they belong (Northern 1991: personal communication).

Carved from a single piece of dense heavy wood, the open mouth reveals a flattened tongue and two rows of squared whitened teeth. The elongated head ends with two spherical knobs composed of concentric rings. The deep black-brown patina has traces of red camwood or clay. This mask is illustrated in dance in a photograph by Tamara Northern taken in 1976. (Illustrated: Anderson and Kreamer 1989: 144; Field photograph: Northern 1984: 149).
– G.G.

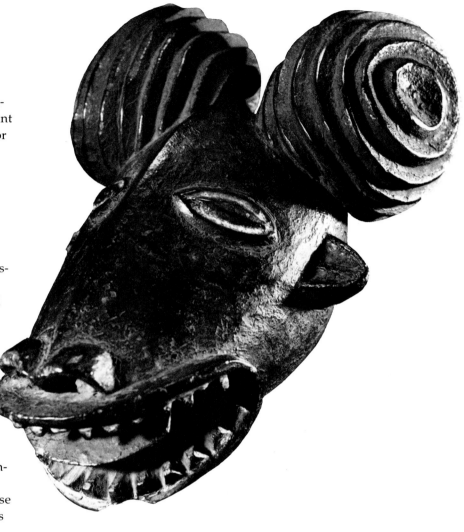

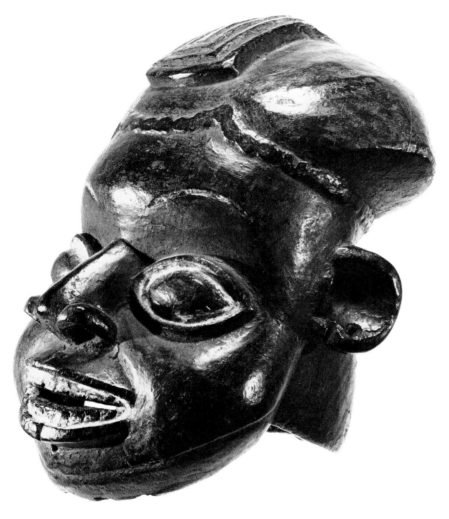

53
KINGDOM OF OKU
Cameroon
16 in. (41 cm.)
wood and pigment
The Graham Collection

In addition to social control and law enforcement, masks make their public appearances on the occasion of commemorative death celebrations for high ranking elders, including members of the *Kwifoyn* regulatory society. Called *Ngoin*, this female mask was photographed in dance in the Kingdom of Oku by Tamara Northern in 1976. It is a lineage mask "characterized by a traditional costume of blue-white resist-dyed royal cloth. The mask dances with short contained steps appropriate to her noble image. *Ngoin*, with her allusion to royal titled wives, serves as a generic symbol of womanhood" (Northern 1984: 146). This mask, along with the goat mask, #52 in this exhibition, was carved and owned by Fai Mankó, who sculpts masks for his own lineage (Northern 1991: personal communication).

This western Grassfields crest has a rich brown patina and features prominent cheeks and a typical female coiffure. Its open mouth displays whitened teeth. (Field photograph: Northern 1986: 54.)
– G.G.

54
TSAYE
Republic of Congo
14.5 in. (37 cm.)
wood and pigment
The Albert F. Gordon Collection

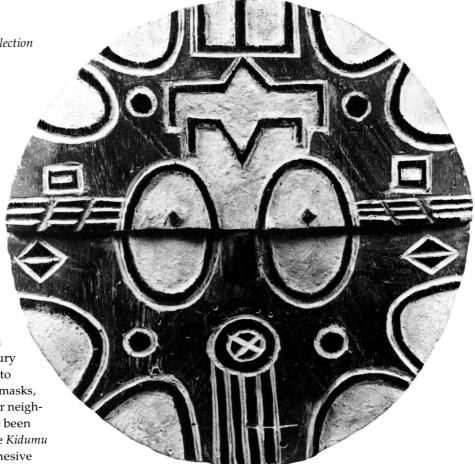

The unique circular flat masks of the Tsaye have long been a source of controversy, since verification of their original 19th-century use is difficult. According to Marie-Claire Dupré, these masks, fequently attributed to their neighbors the Teke, would have been danced by members of the *Kidumu* society, which was the cohesive religious and political force of traditional Tsaye institutions. The symbolic cosmological motifs that decorate the mask have been interpreted in detail. Among them: parallel lines are rainbows; arcs are phases of the moon; circles are stars and insects, and the upper portion refers to the crocodile (Dupré 1979; Lehuard 1972: 12-37).

The mask is carved as though the two hemispheres were joined, with eyes formed as slits at the point of junction. Incised grooves and earth pigments of red, black, and white delineate a highly abstract human face.

– S.B.

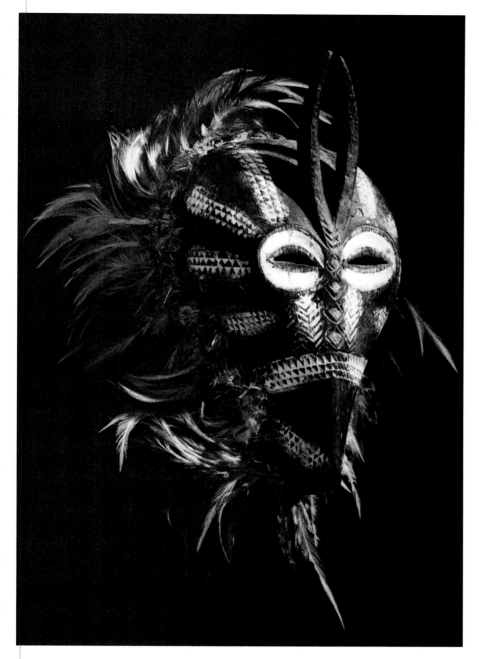

55
BEMBE
Zaire
11 in. (28 cm.)
wood, feathers, and pigment
Penelope Naylor Collection

The sculptural proportions and elegant symmetry of this *Elanda* society mask convey the essence of Bembe artistry. The *Elanda* association, considered the most important institution of social control, is restricted to men who become eligible for membership when they reach marriageable age. Masks are worn following *Elanda* circumcision rites, which are performed at the time of initiation, as well as in ceremonies designed to control supernatural forces (Biebuyck 1972: 18, 19, 75; Neyt 1981: 308).

The slightly concave heart-shaped facial planes are incised with bands of triangular scarification. The eyes are classic Bembe: half-moons within a white kaolin circle. Centered curved antelope horns and feathers framing the mask circumference denote reverence for the powerful forest spirits. (Illustrated: Neyt 1981: 308.)
– S.B.

56
SUKU
Zaire
22 in. (56 cm.)
wood, pigment, and raffia
The Graham Collection

When Suku boys come of age they
are taken to an initiation camp for
circumcision. They remain in the
camp for one to three years, learning
appropriate adult behavior in Suku
society. This mask would be danced
by the young initiates after complet-
ing their training. The white color
may refer to the spirit world of the
sacred camp from which these young
men emerge as adults (Bourgeois
1984; Biebuyck 1985).

The helmet mask has a raffia cowl,
white kaolin covered face with small
upturned nose, pierced crescent eyes,
high arched eyebrows, and circular
scarifications on the cheeks. The cap-
like incised coiffure is surmounted by
a standing animal.
– G.G.

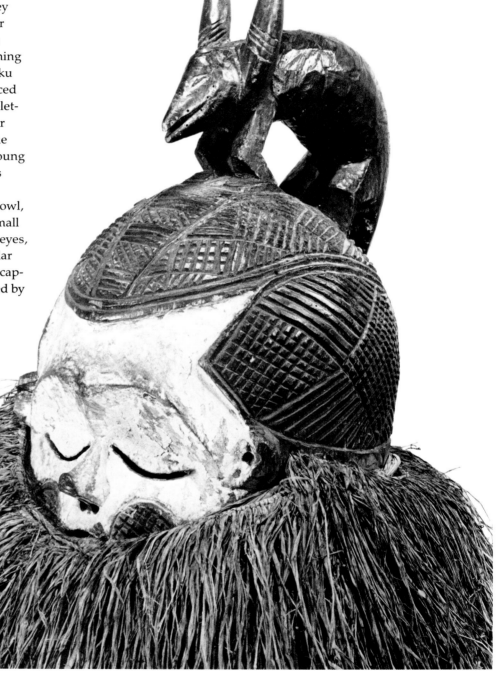

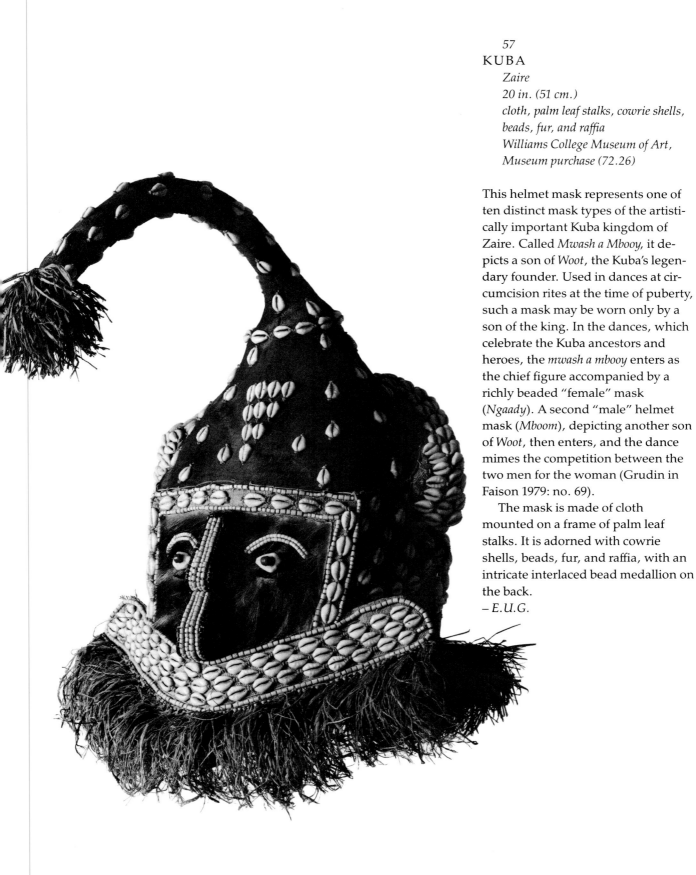

57
KUBA
Zaire
20 in. (51 cm.)
cloth, palm leaf stalks, cowrie shells,
beads, fur, and raffia
Williams College Museum of Art,
Museum purchase (72.26)

This helmet mask represents one of ten distinct mask types of the artistically important Kuba kingdom of Zaire. Called *Mwash a Mbooy*, it depicts a son of *Woot*, the Kuba's legendary founder. Used in dances at circumcision rites at the time of puberty, such a mask may be worn only by a son of the king. In the dances, which celebrate the Kuba ancestors and heroes, the *mwash a mbooy* enters as the chief figure accompanied by a richly beaded "female" mask (*Ngaady*). A second "male" helmet mask (*Mboom*), depicting another son of *Woot*, then enters, and the dance mimes the competition between the two men for the woman (Grudin in Faison 1979: no. 69).

The mask is made of cloth mounted on a frame of palm leaf stalks. It is adorned with cowrie shells, beads, fur, and raffia, with an intricate interlaced bead medallion on the back.
– E.U.G.

58
LUBA
Zaire
16.5 in. (42 cm.)
wood and pigment
The Graham Collection

The *Kifwebe* society uses these masks to enforce proper social behavior, enthrone a new chief, bury society members, or commemorate the death of a chief or other notable. The mask is attached over the face of the dancer, who wears a roughly woven costume and often carries sticks in his hands (Cornet 1978: 276, 277).

This mask is carved from a single piece of light wood. The domed forehead and rectangular face are divided by a prominent medial ridge that develops into the characteristic nose. Jutting beneath the nose is a rectangular tapering mouth. Black triangles beneath the eyes and mouth represent the forest to which spirits return. The incised polychromed stria symbolize the earth and underworld from which spirits emerge. The black ridge is believed to give spiritual protection to the mask during performance (Neyt 1981: 248-250).
– G.G.

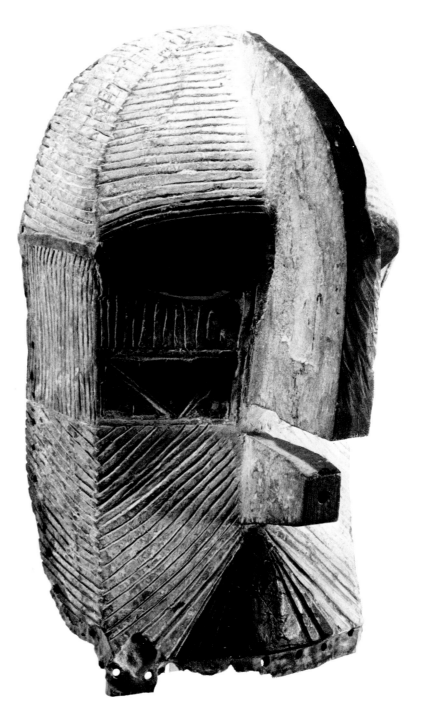

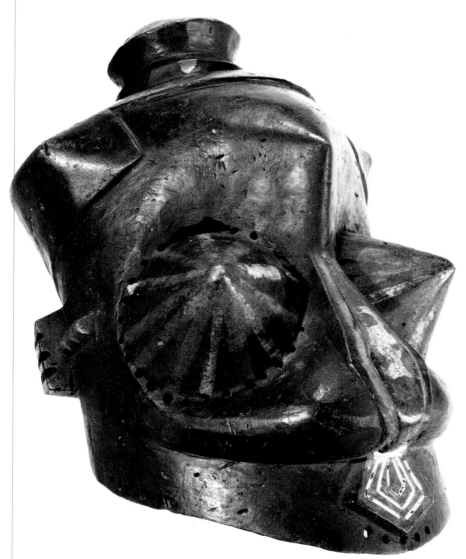

59
BIOMBO
Zaire
18 in. (46 cm.)
wood and pigment
The Graham Collection

The Biombo are a small group who live at the junction of the Lulua and Kasai rivers in south-central Zaire. These rare masks, called *Muluala*, are believed to have been used during initiation ceremonies and at important funerals. The pattern on the nose recalls the beaded decorations of the royal masks made by the Biombo's northern neighbors, the Kuba (Felix 1987: 14).

The mask features typical conical eyes ringed with small perforations for vision, a bulging pointed forehead, and a bulbous nose, carved and decorated with polychrome. The ears are large incised semicircles, and a knob-like protrusion sits atop the coiffure. The bulging eyes and forehead suggest forces within trying to burst out. Rich dark patina and beautiful old repairs on the back indicate generations of use.
– G.G.

60
BUDJA
Zaire
21 in. (52 cm.)
wood, pigment, and raffia
The Graham Collection

Although the Budja people were first
mentioned in a 1910 publication, these
headcrests were not described until
1986 when President Mobutu invited
the King of Belgium to tour northern
Zaire. Photographed in dance by a
member of the King's entourage at
that time, the crest is believed to be
used in agrarian festivities and to
favor the hunt (Felix 1987: 18).

The flat abstract dance crest is inset
in a split-cane support and surround-
ed by fiber. The upper portion suggests
a stylized antelope-*cum*-bird, and a
snake pattern is repeated below; the
pattern is varied on either side.
– G.G.

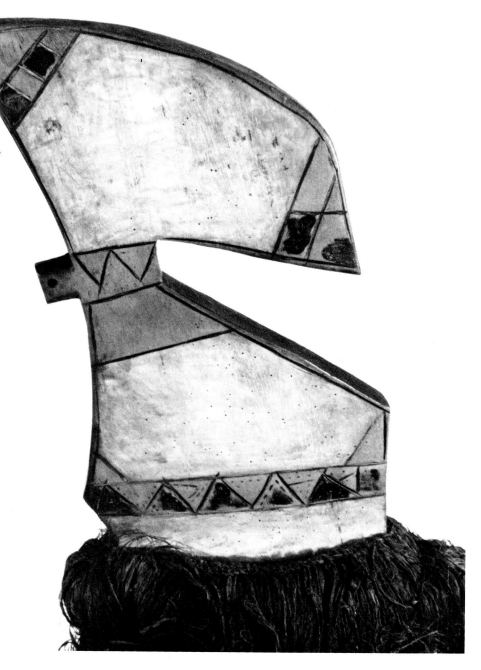

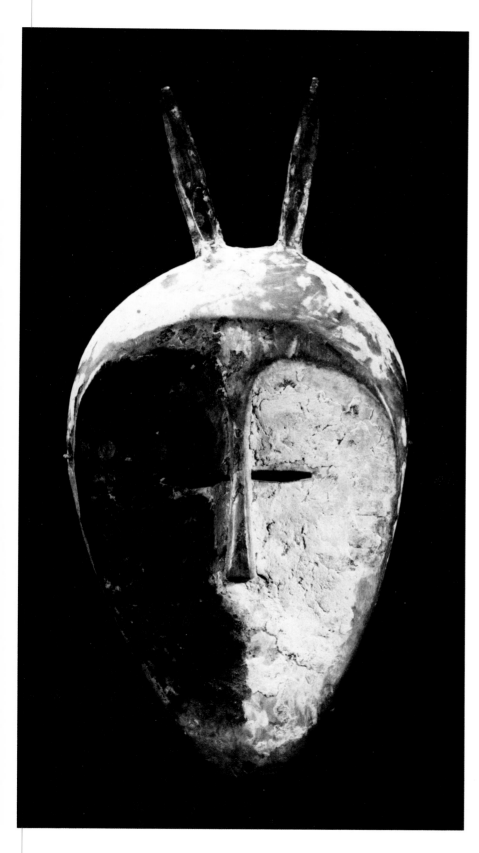

61
LEGA
Zaire
17 in. (44 cm.)
wood, pigment, and fiber
The Graham Collection

This *Kayamba* mask was reserved for use by a senior member of the *Bwami* society. To the Lega, *Bwami* represents the ultimate goal, the essence of life. Advancement from the lowest to the higher ranks of *Bwami* depends on character, family relationships, wealth, and moral qualities learned through initiation. The moral philosophy of *Bwami* is taught with proverbs, dances, carved objects, and masks. Unlike most *Bwami* society masks that are only ritually displayed, this mask would have been danced (Biebuyck 1973: 66).

This rare *Bwami* society heart-shaped mask, with gently tapering chin and narrow nose, rises to an arched brow from which two small horns project. The single hole at the center of the chin may have been for banana-fiber beard attachment. Strongly divided into black and white, the black half displays faint reddish "leopard" spots. (Illustrated: Anderson and Kreamer 1989: 107.)
– G.G.

62
LEGA
Zaire
15 in. (36 cm.)
wood and pigment
The Graham Collection

Although most Lega masks are symbols of rank used in *Bwami* society ceremonies and rites, this anthropozoomorphic mask was danced by the *Aniota* (leopard) society. The forehead spot markings make an obvious reference to the leopard. According to Marc Felix, the overall form, the ear shape, as well as the facial markings are characteristic of the northeast Lega country (1990: personal communication).

The elongated oval mask has gently sloping sides. The typical heart-shaped face displays clan markings on the cheeks and round depressions on the forehead. Pale wood can be seen beneath thinning layers of kaolin pigment. This mask was collected between 1935 and 1945 by a Belgian colonial officer.
– G.G.

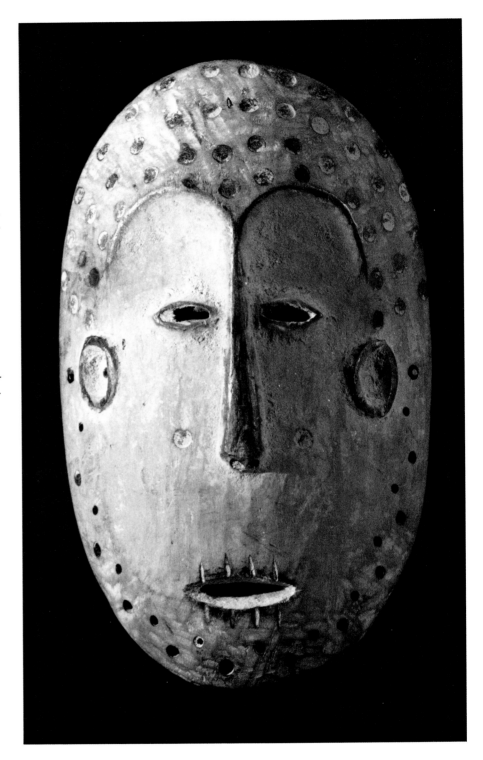

SELECTED
BIBLIOGRAPHY

Adams, Monni. *Designs For Living*. Cambridge: Peabody Museum of Archaeology and Ethnology and Harvard University Press, 1982.

Anderson, Martha G., and Christine M. Kreamer. *Wild Spirits Strong Medicine: African Art and the Wilderness*. New York: The Center for African Art, 1989.

Blier, Suzanne Preston. *Beauty and the Beast: A Study in Contrasts*. New York: Tribal Arts Gallery, 1976.

Biebuyck, Daniel P. *The Arts of Zaire: Volume I, Southwestern Zaire*. Berkeley and Los Angeles: University of California Press, 1985.

_____. "Bembe Art." *African Arts* 5, no. 3 (1972).

_____. *Lega Culture: Art, Initiation and Moral Philosophy Among a Central African People*. Berkeley and Los Angeles: University of California Press, 1973.

Boone, Sylvia A. *Radiance from the Waters: Ideals of Feminine Beauty in Mende Art*. New Haven: Yale University Press, 1986.

Borgatti, Jean M., Richard Brilliant, and Allen Wardell. *Likeness and Beyond: Portraits from Africa and the World*. New York: The Center for African Art, 1990.

Bourgeois, Arthur P. *Art of the Yaka and Suku*. Meudon: Alain et Françoise Chaffin, 1984.

Brain, Robert. *Art and Society in Africa*. New York: Longman, 1980.

Bravmann, René A. "Gur and Manding Masquerades in Ghana." *African Arts* 3, no. 1 (1979).

Celenko, Theodore. *A Treasury of African Art from the Harrison Eiteljorg Collection*. Bloomington: Indiana University Press, 1983.

Cole, Herbet M., ed. *I Am Not Myself: The Art of African Masquerade*. Los Angeles: Museum of Cultural History, University of California at Los Angeles, 1985.

Cole, Herbert M., and Chike Aniakor. *Igbo Arts: Community and Cosmos*. Berkeley and Los Angeles: University of California Press, 1984.

Cornet, Joseph. *A Survey of Zairian Art: The Bronson Collection*. Raleigh: North Carolina Museum of Art, 1978.

Drewal, Henry John. *African Artistry: Technique and Esthetics in Yoruba Sculpture*. Atlanta: The High Museum of Art, 1980.

_____. "The Arts of Egungun Among the Yoruba People." *African Arts* 11, no. 3 (1978).

_____. *Shapes of the Mind: African Art from Long Island Collections*. Hempstead: Hofstra University, 1988.

_____. *Traditional Arts of the Nigerian Peoples: The Milton D. Ratner Family Collection*. Washington, D.C.: Museum of African Art, 1977.

Drewal, Henry John, and Margaret Thompson Drewal. *Gelede: Art and Female Power Among the Yoruba*. Bloomington: Indiana University Press, 1983.

Drewal, Henry John, John Pemberton III, and Roland Abiodun. *Yoruba: Nine Centuries of African Art and Thought*. New York: The Center for African Art and Harry N. Abrams, 1989.

Drewal, Margaret Thompson, and Henry John Drewal. "Gelede Dance of the Western Yoruba." *African Arts* 8, no. 2 (1975).

Dupré, Marie-Claude. "Apropos du Masque Téké de la Collection Barbier-Müller." *Connaissance des Arts Tribaux: Bulletin du Musée Barbier-Müller* 2 (1979).

Eyo, Ekpo. *Two Thousand Years of Nigerian Art*. Lagos, Nigeria: Department of Antiquities, 1977.

Ezra, Kate. *Art of the Dogon: Selections from the Lester Wunderman Collection*. New York: The Metropolitan Museum of Art, 1988.

Fagg, William, and John Pemberton III. *Yoruba Sculpture of West Africa*. New York: Alfred A. Knopf, 1982.

Faison, S. Lane, Jr. *Williams College Museum of Art: Handbook of the Collection*. Williamstown: Williams College Museum of Art, 1979.

Felix, Marc L. *100 Peoples of Zaire and Their Sculpture: The Handbook*. Brussels: Zaire Basin Art History Foundation, 1987.

Fischer, Eberhard. "Dan Forest Spirit Masks: Masks in Dan Villages." *African Arts* 11, no. 2 (January 1978).

Fischer, Eberhard, and Hans Himmelhaber. *The Arts of the Dan in West Africa*. Zurich: Museum Reitburg, 1984.

Fischer, Eberhard, and Lorence Homberger. *Masks in Guro Culture, Ivory Coast*. Zurich: Museum Reitberg; New York: The Center for African Art, 1986.

Foss, Perkins. "Festival of Ohworu at Evwreni." *African Arts* 6, no. 4 (1973).

Fry, Jacqueline. *Twenty-five Sculptures*. Ottowa: National Gallery of Canada, National Museums of Canada, 1978.

Glaze, Anita J. *Art and Death in a Senufo Village*. Bloomington: Indiana University Press, 1981.

_____. "Woman Power and Art in a Senufo Village" *African Arts* 8, no. 3 (1975).

Goldwater, Robert John. *Senufo Sculpture in West Africa*. New York: The Museum of Primitive Art, 1964.

Griaule, Marcel. *Conversations with Ogotemmeli: An Introduction to Dogon Religious Ideas*. London: Oxford University Press, 1965.

_____. *Masques Dogons*. 2d ed. Paris: Travaux et Mémoires de l'Institute d'Ethnologie 33, Musée de l'Homme, 1963.

Imperato, Pascal James. "Contemporary Adapted Dances of the Dogon." *African Arts* 5, no. 3 (1971).

_____. "The Dance of the Tyi Wara." *African Arts* 4, no. 1 (1970).

_____. "The Last Dances of the Bambara." *Natural History* (April 1975).

Jones, G.I. *The Art of Eastern Nigeria*. Cambridge: Cambridge University Press, 1984.

Larsen, Jack Lenor, with Betty Freudenheim. *Interlacing: The Elemental Fabric*. New York: Kodansha International, Harper and Row, 1979.

Laude, Jean. *African Art of the Dogon: The Myths of the Cliff Dwellers*. New York: The Brooklyn Museum, 1973.

Lehuard, Raoul. "De l'Origine du Masque 'Tsaye'." *Arts d'Afrique Noire* 4 (1972).

Leutzinger, Elsy. *African Sculpture: A Descriptive Catalog*. Zurich: Museum Reitberg, 1978.

Mato, D., and C. Miller III. *Sande: Masks and Statues from Liberia and Sierra Leone*. Amsterdam: Gallery Balolu, 1990.

Neyt, François. *L'Art Eket: Collection Azar*. Paris: Abielle, 1979.

_____. *Traditional Arts and History of Zaire*. Brussels: Société d'Arts Primitifs, 1981.

Nicklin, Keith. "Nigerian Skin-Covered Masks." *African Arts* 7, no. 3 (1974).

Northern, Tamara. *The Art of Cameroon*. Washington, D.C.: Smithsonian Institution, 1984.

_____. *Expressions of Cameroon Art: The Franklin Collection*. Los Angeles: The Los Angeles County Museum of Natural History, 1986.

Oldman, W.O. *Catalogue of Ethnographical Specimens*, no. 59, London, 1908.

Ottenberg, Simon. *Masked Rituals of Afikpo*. Seattle: Henry Art Gallery, University of Washington, 1975.

Robbins, Warren M. (Foreword). *The Sculptor's Eye: The African Art Collection of Mr. and Mrs. Chaim Gross*. Washington D.C.: Museum of African Art, 1969.

Robbins, Warren M., and Nancy Ingram Nooter. *African Art in American Collections: Survey*. Washington D.C.: Smithsonian Institution Press, 1989.

Rood, Armistead P. "Bete Masked Dance: A View From Within." *African Arts* 2, no. 3 (1969).

Roy, Christopher D. *African Sculpture: The Stanley Collection*. Iowa City: University of Iowa Museum of Art, 1979.

_____. *Art and Life in Africa: Selections from the Stanley Collection*. Iowa City: University of Iowa Museum of Art, 1985.

_____. *Art of the Upper Volta Rivers*. Meudon: Alain et Françoise Chaffin, 1987.

Scheinberg, Alfred L. *Art of the Ibo, Ibibio Ogoni*. New York: Endicott-Gutheim Gallery, Inc., 1975.

_____. *Two: Aspects of the Doubled Image in African Art*. New York: Tribal Arts Gallery, 1976.

Schmalenbach, Werner, ed. *African Art from the Barbier-Müller Collection*. Munich: Prestel-Verlag, 1988.

Sieber, Roy, and Roslyn Adele Walker. *African Art in the Cycle of Life*. Washington D.C.: Smithsonian Institution Press, 1988.

Siegmann, William C. *Rock of the Ancestors: Namoa Koni (Liberian Art and Material Culture from the Collections of the Africana Museum)*. Suakoko, Liberia: Cuttington University College, 1977.

Starkweather, Frank. *Traditional Igbo Art*. Ann Arbor: University of Michigan Museum of Art, 1968.

Thompson, Robert Farris. *African Art in Motion*. Los Angeles: UCLA Art Council and University of California Press, 1974.

_____. *Black Gods and Kings: Yoruba Art at UCLA*. Los Angeles: Museum and Laboratories of Ethnic Arts and Technology, 1970.

Thonner, Franz. *Du Congo à l'Ubangi, Mon Deuxième Voyage dans l'Afrique Centrale*. Brussels: Société Belge de Librairie, 1910.

Vogel, Susan Mullin, ed. *For Spirits and Kings: African Art from the Paul and Ruth Tishman Collection*. New York: The Metropolitan Museum of Art and Harry N. Abrams, Inc., 1981.

Williams, Drid. "The Dance of the Bedu Moon." *African Arts* 2 (1968).

Wittmer, Marciline K., and William Arnett. *Three Rivers of Nigeria: Art of the Lower Niger River, Cross and Benue*. Atlanta: The High Museum of Art, 1978.

Wolff, Norma H. "Egungun Costuming in Abeokuta." *African Arts* 15, no. 3 (1982).

Zahan, Dominique. *The Bambara*. Leiden: E.J. Brill, 1984.

CREDITS